OREGON STATE
FOOTBALL

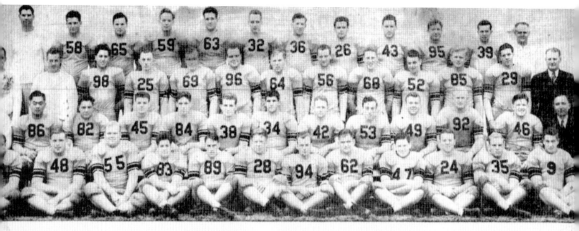

WELCOME HOME, O.S.C.

THE BEAVERS' RETURN HOME from the 1942 Rose Bowl prompted the Portland Gas and Coke Company to run this advertisement in a Portland newspaper.

BACKGROUND: This is the 1895 football team from Oregon Agricultural College.

FRONT COVER: Oregon State University (OSU) head coach Dee Andros gestures to the crowd during the Beavers' 3-0 win over No. 1-ranked University of Southern California in 1967.

BACK COVER: OSU fans get their first look at the view from the upper deck of Reser Stadium's new east grandstand in 2005.

OREGON STATE
FOOTBALL

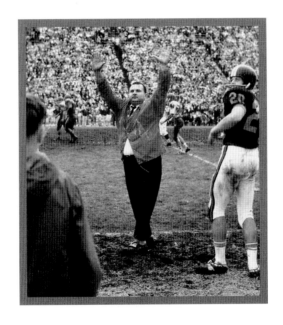

Kip Carlson

ARCADIA
PUBLISHING

Published by Arcadia Publishing
Charleston SC, Chicago IL, Portsmouth NH, San Francisco CA

Printed in the United States of America

Library of Congress Catalog Card Number: 2006923346

For all general information contact Arcadia Publishing at:
Telephone 843-853-2070
Fax 843-853-0044
E-mail sales@arcadiapublishing.com
For customer service and orders:
Toll-Free 1-888-313-2665

Visit us on the Internet at www.arcadiapublishing.com

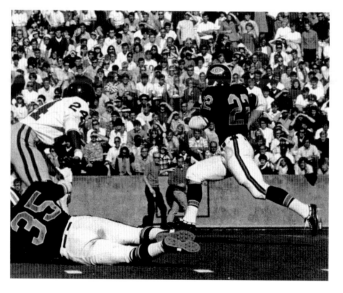

It is OCTOBER 4, 1969, and OSU's Billy Main, No. 22, is running for daylight against the University of Southern California (USC) Trojans. It is the first Oregon State football game ever attended by the author, a 6-year-old accompanying his father and grandfather. The Beavers scored first that afternoon on a run by Bryce Huddleston, then no. 5-ranked USC scored everything else in a 31-7 victory in front of 38,013 people.

CONTENTS

ACKNOWLEDGMENTS

Thanks go to OSU sports information director Steve Fenk, OSU sports information director emeritus Hal Cowan, former *Oregon Stater* editors George Edmonston Jr. and Chuck Boice, Larry Landis and the staff at the OSU archives, and the numerous photographers who have shot games for OSU's sports information office over the years for their knowledge and talents in helping compile this book.

Finally this book is dedicated overwhelmingly to the memory of my father Darrell Carlson and his father Albert Carlson—thanks for not only those afternoons with the Beavers but for everything else you gave me as well.

This book is also dedicated to my mother, Elizabeth Carlson, and my brothers Hans and Nels Carlson and their families—Bonnie, Stephan, and William; and Allison, Dane, Birgitta, and Annika— all of whom have been backing the Beavers since before the glory returned in the late 1990s and who steadfastly climb high into the west grandstand at Reser Stadium for home games each fall. Finally this is for Tracy Loew and Katie Thomas, who are my reminders that there is something out there besides sports.

INTRODUCTION

It was my father and his father who introduced me to Oregon State football at the all-too-impressionable age of six back in 1969. In the years since, there have been times—like, say, the 1970s and 1980s—when it was difficult to decide whether they deserved credit or blame for that act.

The two of them packed me off to Parker Stadium on October 4, 1969, to watch the Beavers play No. 5-ranked University of Southern California. At least the Beavers scored the first touchdown I would ever see at an OSU game, but I don't recall that part. What I do remember from that afternoon was asking why, with so much time left on the clock, were people already leaving? Well, with the home team on the way to a 31-7 loss, it's what people did.

By the mid-1970s, it was my grandfather and I who had taken to going to every home game together, sitting in the splintered bleachers under the scoreboard beyond the south end zone. It continued into the 1981 season. By then, grandpa's health wasn't the greatest, but he hauled himself up to his favorite seat for the season opener against Fresno State. OSU trailed 28-0 early in the third quarter, and grandpa had had enough and headed for home. The Beavers rallied to win 31-28, which at the time was the largest deficit a team had overcome to win a NCAA Division I game. As I recall, grandpa's reaction was along the lines of, "It figures."

As the beatings went on under a series of head coaches at OSU, I attended Linfield College and became aware that you could follow a college football team that posted winning records. After graduation came 11 years at newspapers in Roseburg and Corvallis, and those jobs included some coverage of OSU football. Next was a job in Oregon State's sports information office and the fortuitous turn of events that allowed an up-close view of head coaches Mike Riley and Dennis Erickson turning the Beavers back into winners.

It was worth the wait.

This is an opportunity to share some images and bits of information that make the history of OSU football interesting. This book is not intended as a critical, comprehensive history of Oregon State football; not every great play, great player, and great game will be found here. Rather, it is presented as a series of vignettes—tidbits about people and events that may give a greater appreciation for what has happened in the years since the school began playing varsity football in 1893. Wrote the *Corvallis Gazette* of that first-ever game, a 62-0 win over Albany College on November 11, 1893:

> The first football game ever played in our city was played last Saturday between the Albany College and the state agricultural college elevens. At about eleven o'clock the members of the Albany team came over in hacks and were met by Messrs. Bloss and Burnett of the O.A.C. team. As soon as the horses had been taken care of the men were escorted to the Cauthorn

Hall where dinner was prepared for them. At one o'clock the college band marched through the town playing a few lively quicksteps and then all repaired to the college parade grounds. The general public was charged admission to the grounds and tickets were sold at ten cents apiece. This was done to defray expenses. Fully 500 people witnessed the contest. Tin horns of all sizes and tones, some very nicely decorated with college colors were brought along. Enthusiasm ran high during the game and amid the squeaking of horns and ringing of the college yell of 'Zip boom bee! Zip boom bee! O.A.C.! O.A.C.!' one could hardly think. The ladies were so excited that they actually yelled and followed with interest every move of the players. . . . After the game the Albany men were invited out to supper by Judge Burnett who had been an interested beholder of the game. The repast was thoroughly enjoyed to say the least. The team returned home in the evening.

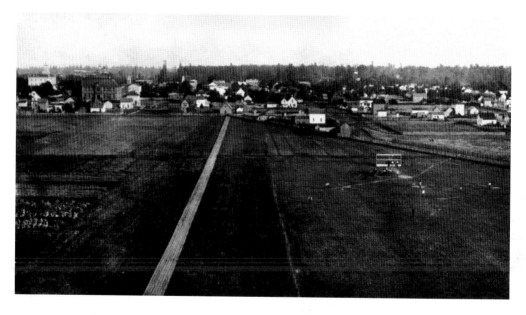

THIS IS A BIRD'S-EYE VIEW of the athletic field at Oregon Agricultural College in 1893, when the school played its first football game. The photograph was apparently taken from the top floor or the roof of Benton Hall, looking east toward downtown Corvallis. At the moment, a baseball game is being played; for football season, a gridiron was laid out running from the top of the image toward the bottom. The approximate location of the backstop now has SW Jefferson Avenue running through it. The white building at far left is the Benton County Courthouse, and the large building just to its right is the old Central School. The boardwalk leading to Benton Hall was famous at the time and very necessary, as there was no drainage in this area, and from time to time it was possible to boat in the lower campus.

1 8 9 3 – 1 9 3 2

WHEN THE PRESIDENT'S SON wants a football team, he starts a football team—that's the short version of how the sport began at Oregon State, then known as the Oregon Agricultural College (OAC) Aggies, in 1893. Bill Bloss, a graduate of Purdue University and the son of OAC president John M. Bloss, was the player/coach on the school's first football team that year. For the next three decades, the program went through its formative stages under a number of coaches, eventually playing a conference schedule and games from coast to coast.

THE COACHES: Bill Bloss, 1893, 1897; Guy Kenney, 1894; Paul Downing, 1895; Tommy Code, 1896; no coach in 1898; Highland Stickney, 1899; no football, 1900–1901; Frank Herbold, 1902; McFadden, 1903; Allen Steckle, 1904–1905; F. S. Norcross, 1906–1908; Sol S. Metzger, 1909; G. Schildmiller, 1910; Sam Dolan, 1911–1912; E. J. Stewart, 1913–1915; Joseph Pipall, 1916–1917; W. H. Hargiss, 1918–1919; R. B. Rutherford, 1920–1923; and Paul J. Schissler, 1924–1932.

THE ALL-AMERICANS: Herman Abraham, halfback, 1916; George "Gap" Powell, fullback, 1921; and Howard Maple, quarterback, 1928.

THE GOLDEN YEARS: In 1893, 4-1 record; in 1902, 4-1 record; in 1906, 4-1-2 record; in 1907, 6-0 record and were not scored upon; in 1914, 7-0-2 record; in 1925, 7-2 record; and in 1926, 7-1 record.

THE WAIT-'TIL-NEXT-YEARS: In 1895, 0-2-1 record.

THE BEST OF TIMES: In 1893, beat Albany College 62-0 in Corvallis in first-ever game; in 1894, beat Oregon 16-0 in Corvallis in first-ever "Civil War" rivalry game; in 1915, beat highly regarded Michigan State University 20-0 in East Lansing, Michigan, in first trip away from West Coast region; in 1928, beat highly regarded New York University 25-13 at Yankee Stadium; in 1930, beat West Virginia 12-0 in benefit game in Chicago; and 1931, beat Willamette University 76-0 in Corvallis to set school scoring record.

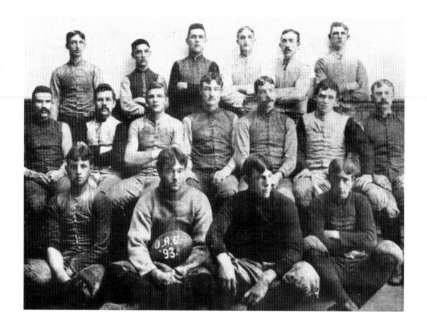

THIS 1893 OREGON AGRICULTURAL COLLEGE football team started it all. The members pictured here, from left to right, are (first row) Ralph W. Terrell, Will H. Bloss, Percival Nash, and Brady F. Burnett; (second row) Charles Small, John F. Fulton, Henry M. Desborough, Harvey L. McAlister "Pap Hayseed," D. H. Bodine, Des Nash, and Charles L. Owsley; (third row) Harry W. Kelly, Arthur Lambert, Thomas Beall, E. Arthur Buchanan, William Abernathy, and Clem "Turkey" Jones. As can be seen, these lads may not have had numerals on their jerseys but were still inclined to personalize their playing gear. Bloss was the coach and Burnett the captain that first season, and the future Beavers went 4-1.

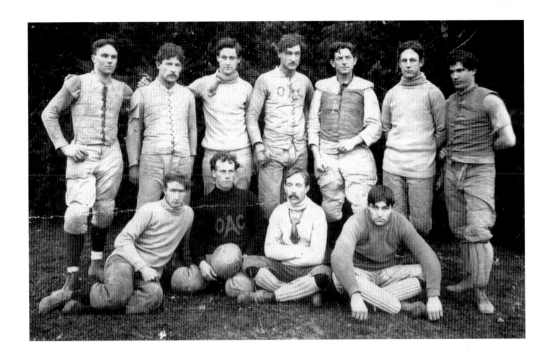

TWO YEARS AFTER OREGON AGRICULTURAL College played its first varsity game, the 1895 team takes advantage of advances in protective equipment. Note the nose guard around the neck of the player in the front row, the padded leggings worn by several others, and the shoulder flaps on the jackets of others that were worn for their 0-2-1 season.

BY 1906, OAC'S HOME FIELD had been moved just south of the gymnasium, which is now Gladys Valley Gymnastics Center, next to Education Hall. About 1,300 people saw the Aggies play Oregon University to a 0-0 tie. Carl Wolff nearly gave OAC the victory, but missed a field goal attempt wide by about a foot.

OREGON STATE FOOTBALL

THE STERN GENTLEMAN AT FAR left is George Schildmiller, who was in his only season as OAC's coach in 1910. Oregon Agricultural College went 3-2-1.

IN 1913, THE CIVIL WAR was held for a second straight year in Albany. In the mud, Oregon rallied in the fourth quarter to earn a 10-10 tie with Oregon Agricultural College. Moving the game to a neutral site seemed the only way to resume the rivalry between OAC and Oregon. The 1910 game engendered such bitter behavior between students and supporters of the two institutions that the Aggie student body severed athletic relations with Oregon, and the teams didn't play in 1911. In 1912, school officials agreed to Albany as a neutral site. An Albany businessman offered to build seating for 10,000 fans, and it was completed a few days before the game, which was won by Oregon 7-0 in front of 7,000 attendees. Members of the student bodies were forbidden from walking into downtown Albany before or after the game, and they entered the stadium through separate gates.

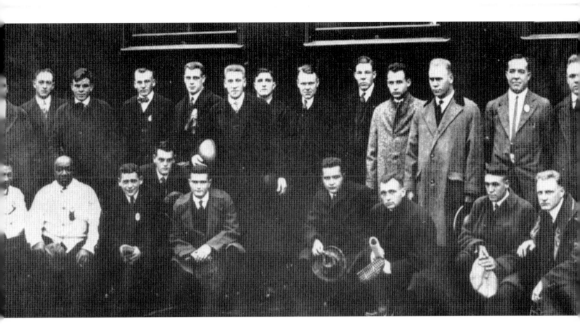

OAC's 1915 TEAM POSES with some railroad workers. The Aggies went to Michigan Agricultural (now Michigan State University) and won 20-0. Not long before, the Michigan Aggies had beaten one of legendary coach Fielding Yost's University of Michigan teams 24-0. That prompted Grantland Rice to pen the following in the *New York Tribune*, under the headline "The Pacific Slump":

'Football in the Far West is at low tide.'
—general comment
Michigan Aggies 24, Michigan University 0
Oregon Aggies 20, Michigan Aggies 0
How sad to think about the slump
That's soaked the distant West!
To think how far their teams have dropped
Below the laureled crest;
To think that in that land along
The old Pacific's rim
They haven't any stalwarts left
To play the game with vim;
They haven't any team at all
From all their ragged hosts—
Except a team that crushed a team
That smashed a team of Yost's.
Ah yes, it's sad to think about
The old Pacific slump,
The way the West has hit the chute
And hit it with a bump;
But when you speak of things like this
In a manner somewhat free,
Don't mention it at Michigan
Or up at M.A.C.;
They haven't any stuff at all
To call for Autumn boasts
Except a team that smeared a team
That smashed a team of Yost's.

The win helped garner All-America honors in 1916 for halfback Herman Abraham (back row, fourth from left) from Albany, Oregon. Head coach E. J. Stewart is in the back row, at far left.

OREGON STATE UNIVERSITY AND THE University of Notre Dame didn't meet on the field until the 2001 Fiesta Bowl and the 2004 Insight Bowl, but the relationship between the two schools' football programs dates back to the 1920s. From 1925 through 1929, legendary Notre Dame head coach Knute Rockne taught in the coach's school at the Oregon State College (OSC) summer session. He's pictured here (opposite, above, just to the right of the linemen with hands on knees) running drills on Bell Field. The advertisement for the session on the back cover of a 1926 football program (opposite, below) bills him as one of the "Four Horsemen" of the summer session along with OSC coaches Bob Hager, Ralph Coleman, and Paul Schissler.

Schissler was one reason Rockne had that connection with Corvallis. Schissler's team from tiny Lombard College stayed within 14-0 of Rockne's 1923 Notre Dame team, and Rockne took note of the young coach, who moved to OAC the next season. Rockne had also been a pupil of "Dad" Butler in the Midwest before Butler went on to develop some powerful Beaver track and field teams in the 1910s and 1920s. After the 1928 session, Rockne used his nationally syndicated newspaper column to comment on athletics in the Pacific Northwest in general and Oregon in particular. He wrote:

> In the average person's mind, the state of Oregon is associated with the covered wagon. Emerson Hough, in a recent story, drew an epic picture of that great trek across the plains, over the mountains and down the Columbia river to Oregon. Many people living in Oregon today are descendants of those dauntless pioneers . . . in this Pacific northwest, it is natural that the descendants of these men who first settled the country should be athletically inclined.

After commenting on various track and field, crew, baseball, and basketball standouts from the region, Rockne added, "It is in football, however, that this country really excels. The big, rugged boys brought up in the woods and on the ranches are natural timber for this strenuous combat game." He concluded with this, "One high school coach said to me, 'How would you like to live out here in the open spaces, where the men are men?' And I said, 'No, the competition is too keen. I would rather go where all the men are not.'"

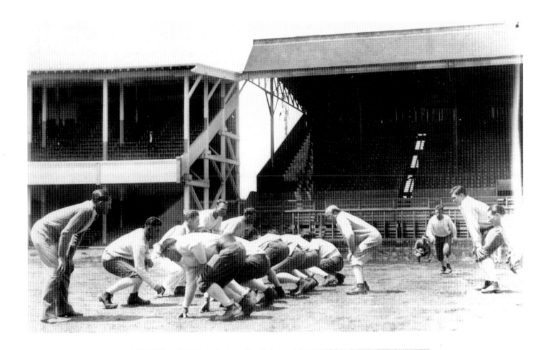

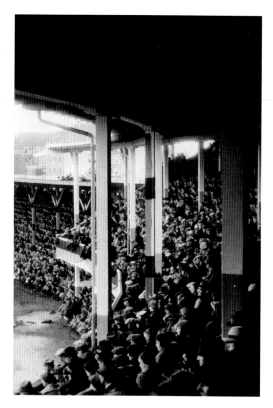

THE DOUBLE-DECKED SEMICIRCLE at the south end of Bell Field was built in 1924, adding 11,000 seats to the stadium to bring capacity to 18,000. This is a good look at the wooden construction of the structure, which cost $21,000. Fans had to peer around not just one row, but three rows of posts. Waldo Hall is in the background.

THE RUNNER DEPICTED ON THE cover of the 1926 Civil War program would have found slow going, as the game was played on an extremely muddy Bell Field. The conditions helped limit the scoring through three quarters to a lone field goal by Oregon Agricultural College's Wes Schulmerich. In the fourth quarter, though, Howard Maple scored twice to make the final 16-0. The Beavers finished with a 7-1 record and had one of the nation's top-rated defenses that season, outscoring its opponents 221-30 and posting five shutouts.

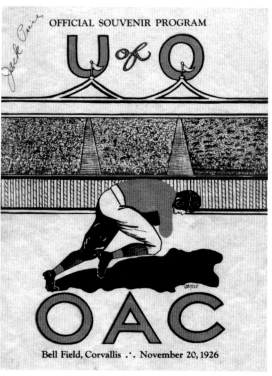

OFFICIAL SOUVENIR PROGRAM

U of O

OAC

Bell Field, Corvallis ∴ November 20, 1926

FOOTBALL

Oregon State

VS.

New York University
YANKEE STADIUM

Thanksgiving, Nov. 29, at 1:30 P. M.

Tickets on Sale at

Yankee Baseball Offices, 226 W. 42d St.
A. G. Spalding & Bros.
103 Nassau St. 518 Fifth Ave.
Alex Taylor, 22 E. 42d St.
All Davega Stores

BY THE LATE 1920S, Oregon State could feel like it was in the big leagues—literally. The Beavers played several games in major-league baseball stadiums, including Yankee Stadium in 1928 and the Polo Grounds in 1932 and 1933. Oregon State beat New York University 25-13 in "the house that Ruth built" in 1928, lost to Fordham University 8-6 in 1932, and then beat Fordham 9-6 in 1933 at the Polo Grounds.

FORDHAM VS.
OREGON STATE
TOMORROW (2 P. M.)
POLO GROUNDS

General Admission **$1.10** | Reserved Seats **$1.65**

(including tax)

IT WAS THE FIRST TIME that a college football team from the West Coast had played on the East Coast, and the western representative, Oregon State, wasn't expected to give the New York University (NYU) Violets much of a struggle at the five-year-old Yankee Stadium. The Beavers were referred to in one New York newspaper as "the student-peasants from the rain belt" and were rated 3-to-1 underdogs the morning of the game.

Indeed NYU rolled to a touchdown less than five minutes into the game, and a crowd of 40,000 sat back to watch the expected rout. Oregon State bounced back for a 19-point second quarter, though, with a display of passing and misdirection plays that set the Violets on their heels. Cecil Sherwood and Carl Gilmore ran for touchdowns and Howard Maple passed to Bill McKalip for another.

"The game was a revelation to those closely identified with football," wrote Walter Eckersall of the *Chicago Tribune Press Service*, who was also part of the game's officiating crew. "New York had been doped to win by a one-sided score. The Aggies simply went into the game determined to score by use of the lateral and forward pass and they did. New York was unable to cope with this aerial attack, which was mixed with quick opening plays in which the Aggies' forwards cooperated splendidly with the backs."

Henry "Honolulu" Hughes rushed for the Beavers final touchdown before NYU managed to score in the final moments. When it was over, New York columnist Bill Corum wrote, "It goes to show that you never can tell about a country boy in the big city. Every time a subway train passed the Stadium yesterday, one of those Aggies grabbed the ball and started for the station. They thought it was time they were getting back to Corvallis. So did the NYU rooters."

Upon returning to the state, the Beavers received a number of welcoming rallies, including a dinner at the Multnomah Hotel in Portland at which Gov. I. L. Patterson honored them. That night in Corvallis, a crowd of 4,000 greeted them at the station and proceeded to the brand-new Memorial Union for a victory dance; the next day, 3,000 jammed the college gymnasium for a special convocation.

"The way they played at New York, they could have beaten almost any team," Schissler said of the Beavers. "I talked with a veteran newspaper man after the game, one who has been covering football for 15 years, and he said the Aggie club was the best, at least that day, he had ever seen in action."

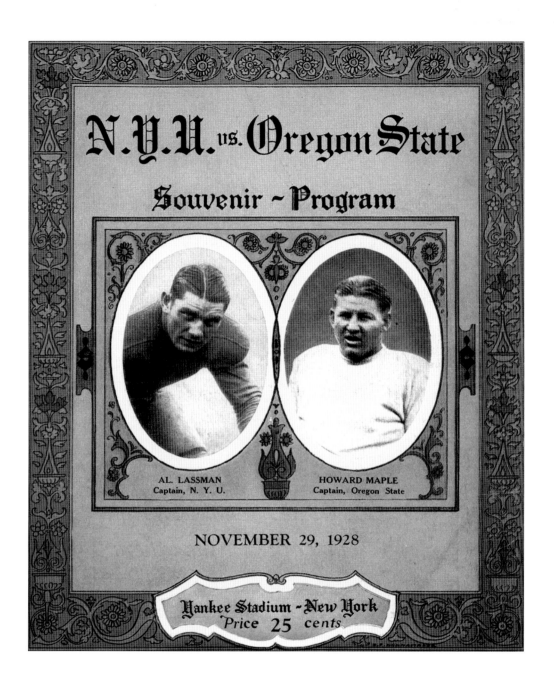

N.Y.U. vs. Oregon State

Souvenir ~ Program

AL. LASSMAN
Captain, N. Y. U.

HOWARD MAPLE
Captain, Oregon State

NOVEMBER 29, 1928

Yankee Stadium ~ New York
Price 25 cents

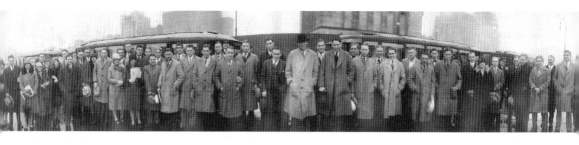

OREGON STATE'S 1928 VISIT TO play New York University at Yankee Stadium included not only a 25-13 win, but also a chance to see the city; here the Beavers stand in front of their motor coaches for a group portrait. The *Corvallis Gazette-Times* reported that a telegram from head coach Paul Schissler after the game said the Beavers "are in great demand in New York. Every night club in the city wants them for tonight and tomorrow night. Photographers besiege the men on every corner, and girls are after autographs."

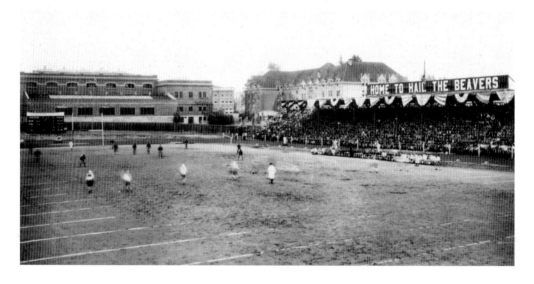

IT IS HOMECOMING IN 1929 and as the marquee above Bell Field's east grandstand reads, the old grads are "Home To Hail The Beavers." The opponent is University of Idaho and Oregon State dominated in a 27-0 win. Fred H. McNeil of the *Oregon Journal* noted of the crowd of 10,000, "The grandstand and the student bleachers were filled and in the horseshoe was a sprinkling of hundreds. There was all the Beaver color here today, a huge rooters section and the justly famous Beaver band. The artillery unit of the ROTC fired a 21-gun salute, shaking the airy grandstand as the colors ran up the staff. A battery of cheerleaders worked themselves into a frenzy before the student stands. The stands were decorated as of yore; and just before the game Oregon State's heroes of past campaigns on the diamond and the grid paraded past them."

OREGON STATE PLAYED ITS FIRST night game at home on September 20, 1930, and the crowd in the east grandstand at Bell Field is watching the Beavers beat Willamette University 48-0. It was the first of four night games in Corvallis that season, with the hope being that evening kickoffs would draw more fans.

The lights were installed in the weeks leading up to the game against Willamette and tested the Wednesday evening prior to the game. One newspaper report noted, "Although few persons knew the lights were to be turned on, a great crowd, whose attention was drawn by the brilliant reflection in the sky, thronged to the stadium." The system was said to be comparable to those at Yankee Stadium, Madison Square Garden, and other places where lights had been put in use in recent years. To allay fears that fans would be subjected to uncomfortably cold temperatures after dark, Oregon State athletics general manager Carl Lodell announced that the back and sides of the west grandstand would be completely boarded up to deflect the coastal winds.

The game against Willamette, the defending Northwest Conference champion, would benefit the Oregon State band by helping raise the funds necessary to send it to Chicago to perform when the Beavers played West Virginia University in the final game of the season. After Frank Little scored a pair of touchdowns to lead the Beavers' romp, night football was declared a success. L. H. Gregory wrote in the *Oregonian* that the crowd of 4,200 "far exceeded that of the Pacific-Oregon daylight game this afternoon at Eugene," and Lodell told him that the crowd was "four times the previous Bell Field record for a preliminary game."

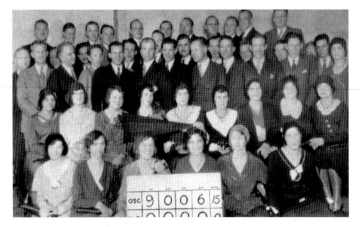

ON NOVEMBER 15, 1930, 48 members of the New York City Oregon State Club gathered to hear telegraphic reports of the homecoming game against Oregon at Bell Field. At game's end, they proudly showed the scoreboard they'd kept throughout Oregon State's 15-0 win.

OREGON STATE'S RENOWNED 60-PIECE band made the trip to Chicago to see the Beavers wrap up their season with a 12-0 win over West Virginia University, leaving Oregon State with a 7-3 record. The musicians traveled in style on the Union Pacific, with the railroad even printing up special menus for the band and the rest of the Oregon State party. The band joined up with the football team partway through what was a long trip for the players. The squad left Corvallis on November 18 to play at UCLA (University of California at Los Angeles), and then they left straight for Chicago before returning home on December 2. A newspaper story noted, "Dr. D. V. Poling, member of the Oregon State faculty, will make the trip to Chicago and see that the boys keep up on their A, B, Cs. Dr. Poling will have classes every morning for three hours." The Beavers, the band, and fans arrived ahead of the West Virginia contingent. The Oregon Staters met the Mountaineers at the station upon their arrival in Chicago, and the bands and fans combined for a parade through the Loop.

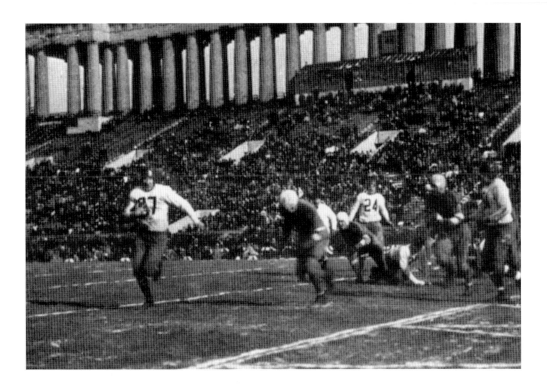

THERE'S A REASON THOSE GREEK columns in the background look familiar. It is Soldier Field in Chicago where Oregon State is playing on Thanksgiving Day, 1930, during a 12-0 win over West Virginia. "Wild Bill" McKalip is racing around right end for one of his two touchdowns on the afternoon. The game was part of a doubleheader to benefit the Shriners hospitals. The other game was an alumni matchup of former players from the University of Notre Dame and Northwestern University, which ended in a scoreless tie. Wrote Albon Holden of the *Chicago Sun-Times*:

> The Shriners sold 57,000 tickets for their crippled children's hospital charity game at Soldier Field and 18,000 of them came

out to see Oregon State defeat West Virginia 12-0. Now the Shriners will have another game to build a hospital to take care of the 18,000 who suffered through the game with the Thanksgiving Day temperature just a few notches above zero. It was a frightful experience and when the battle was over there probably were not more than 5,000 pneumonia victims shivering under blankets in the huge stands, the remainder having long since fled to the hot coffee bazaar under the stands . . . It will probably take a day or two to count up the ticket sales, but with 57,000 announced as disposed of, the Shriners' crippled children's hospital will reap a handsome benefit.

THE FIRST HEAD COACH to put Oregon State football on the national stage on a consistent basis was Paul Schissler (opposite, above, dark shirt), who coached the Beavers from 1924 through 1932. In his nine seasons, which started when the school was known as Oregon Agricultural College and ended with it named Oregon State College, his teams went 48-30-2. The Beavers played at the University of Nebraska, at Marquette University, against Eastern power Carnegie Tech in Portland, against New York University at Yankee Stadium, at Detroit University, against West Virginia University at Chicago's Soldier Field, and against Fordham at the Polo Grounds. In those intersectional games, Oregon State posted a 3-3-1 record. A 25-13 win in 1928 over an NYU team considered the best in the East marked the first time a West Coast team had played on the Eastern Seaboard; a 14-7 win at Detroit University in 1929 ended the Titans' 22-game winning streak.

Schissler got his coaching start with a pair of seasons at Hastings High School in Nebraska before moving up to Doane College in 1915 and then St. Viator College in 1916. After a year out of coaching, he signed on as an assistant football coach and head basketball and baseball coach at Nebraska. In 1920, he was appointed Nebraska's head freshman football coach and guided the Cornhuskers to an undefeated season.

Lombard College in Illinois, where Schissler went to study law, was where he coached from 1921 through 1923. His teams went 23-1-1 and, in a 1923 game, managed to stay within 14-0 of one of legendary Notre Dame coach Knute Rockne's Fighting Irish squads. It was the beginning of a friendship between Schissler and Rockne that lasted until Rockne's death in 1931.

A write-up before Schissler's final season at OSC was described, "Coach Schissler has risen from the ranks without being a star player himself. He is a stickler for details. Discipline is the foundation of the morale of all his teams. He stands for very little fooling around or horse play. It is strictly a matter of business the minute he steps on the football field, and while there he is king of all he surveys, and everybody within sight of him knows it. He, like other successful coaches, has a knack of eliminating non-essentials and lays emphasis on fundamentals and team play."

The Depression played a part in Schissler leaving Oregon State. His contract had three years to run, at $8,000 per year, but the state board of higher education instituted a graduated wage decrease for all its employees that would have lopped 10 percent off Schissler's salary. After Schissler met with chancellor of higher education William J. Kerr in January 1933, his resignation was announced.

After leaving Oregon State, Schissler spent four years as a head coach in the fledgling National Football League and posted a 14-29-3 record with the Chicago Cardinals and Brooklyn Dodgers from 1933 through 1936.

HOWARD MAPLE, A QUARTERBACK from Peoria, Illinois, guided Oregon State to its upset of New York University in 1928 and earned All-America honors. Also a catcher in baseball, he later played in the major leagues for the Washington Senators.

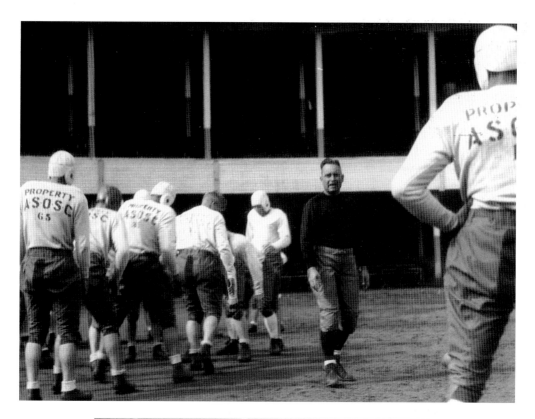

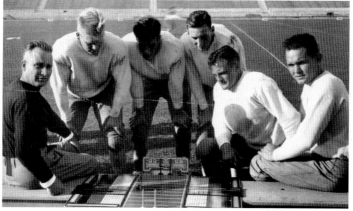

BEFORE THE DAWN OF THE video game, a person could still simulate a football game off the field; it's just that a spinner replaced the control box and the graphics consisted of a tiny football pushed up and down a game board (bottom). Oregon State head coach Paul Schissler is at the far left and a very young Lon Stiner, one of Schissler's assistants, is at the far right. The best guess is that this was taken on one of the Beavers' trips to play the University of Southern California between 1928, when Stiner joined Schissler's staff as line coach, and 1932, when Stiner succeeded Schissler as head coach. The stadium has the look of the Los Angeles Memorial Coliseum and the scoreboard on the game reads "Oregon State 21, U.S.C. 0".

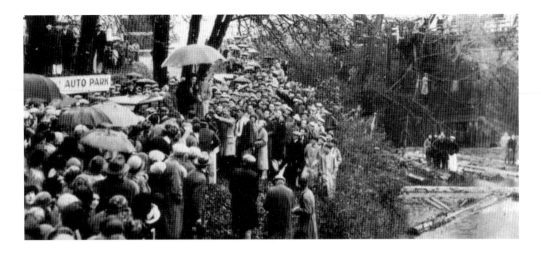

DR. J. R. N. BELL, A BEAVER BOOSTER for whom Bell Field was named, celebrated every football victory over the University of Oregon by throwing his hat into the Mary's River. Here he's pictured with OSC president William Jasper Kerr as most of the Beaver student body watches.

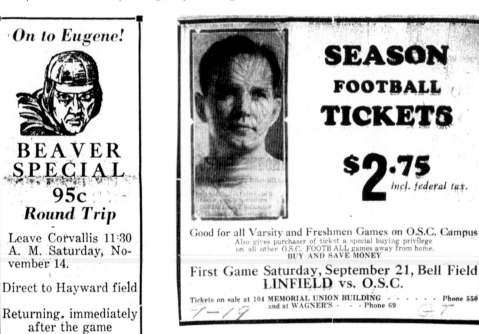

On to Eugene!

BEAVER SPECIAL
95c
Round Trip

Leave Corvallis 11:30 A. M. Saturday, November 14.

Direct to Hayward field

Returning immediately after the game

Phone 58 for Details

—0—

SOUTHERN PACIFIC
Guy L. Ravin, Agent

SEASON FOOTBALL TICKETS

$**2**.75 *incl. federal tax.*

Good for all Varsity and Freshmen Games on O.S.C. Campus
Also gives purchaser of ticket a special buying privilege
on all other O.S.C. FOOTBALL games away from home.
BUY AND SAVE MONEY

First Game Saturday, September 21, Bell Field
LINFIELD vs. O.S.C.

Tickets on sale at 104 MEMORIAL UNION BUILDING · · · · · Phone 550
and at WAGNER'S · · · Phone 69

IN 1935, $2.75 WOULD GET a person in to see all five Oregon State varsity games at Bell Field, plus several contests by the OSC Rooks, or freshman teams. Beaver head coach Lon Stiner (pictured in advertisement above) guided Oregon State to a 31-0 win over Linfield College in the season opener. In 1931, 95¢ got a fan a round-trip rail ticket from Corvallis to Eugene to watch Oregon State and Oregon tie 0-0 at Hayward Field (left).

1 9 3 3 — 1 9 5 4

WITH COLLEGE FOOTBALL'S POPULARITY continuing to grow, Oregon State had its good years and bad years under head coach Lon Stiner. The Beavers tended to be part of the upper-middle class in the Pacific Coast Conference (PCC). After Stiner's departure, Kip Taylor was hired as head coach, and in the following years, Oregon State slid into a string of losing seasons. The era included the opening of a new gridiron for the Beavers, as Parker Stadium was constructed in 1953 with a capacity of 22,000.

THE COACHES: Lon Stiner, 1933–1942, 1945–1948; no football, 1943–1944; Kip Taylor, 1949–1954.

THE ALL-AMERICANS: Red Franklin, halfback, 1933; Ade Schwammel, tackle, 1933; Eberle Schultz, guard, 1939; Vic Sears, tackle, 1940; Quentin Greenough, center, 1941; Bill Gray, center, 1946.

THE GOLDEN YEARS: In 1933, 6-2-2 record and the "Iron Men" tie Southern California; in 1939, 9-1-1 record with a Pineapple Bowl win and ranked as high as No. 11; in 1941, 8-2 record with a Rose Bowl win, ranked as high as No. 12; in 1946, 7-1-1 record; and in 1949, 7-3 record.

THE WAIT-'TIL-NEXT-YEARS: 1934, 3-6-2 record; 1952, 2-7 record; 1954, 1-8 record.

THE BEST OF TIMES: In 1933, tied Southern California 0-0 in Portland to end USC's 25-game winning streak and beat Fordham 9-6 at Polo Grounds; in 1941, beat No. 2 Duke 20-16 in "transplanted" Rose Bowl in Durham, North Carolina; in 1945, beat No. 18 Washington 7-6; in 1949, beat No. 8 Michigan State 25-20 in Portland; and in 1953, beat Washington State 7-0 in Corvallis in the first game at Parker Stadium.

LON STINER (OPPOSITE, IN STRIPED PANTS) oversees the Beavers in a blocking drill in the 1930s. Stiner was the longest-serving head coach in Oregon State football history, guiding the Beavers for 14 seasons from 1933 through 1948 with a 74-49-17 record. He coached two of the most famous squads in school history—the 1933 "Iron Men" who ended Southern California's winning streak at 25 games with a 0-0 tie in Portland, and the 1941 team that won the "transplanted" Rose Bowl 20-16 over No. 2-ranked Duke. "He was easy to work with, although he expected a lot from people . . . was very exacting," said Hal Moe, an assistant coach on Stiner's staff for a number of years. "I thought he was a brilliant coach, particularly in working with young men. He just had a way of dealing with them." Eight of Stiner's teams had winning records, and two more finished at .500 (including a 1937 squad that finished 3-3-3).

Stiner's first Oregon State team—those Iron Men—finished 6-2-2 and took a 9-6 win over Fordham at New York City's Polo Grounds. In 1939, OSC was ranked as high as No. 11 on the way to a 9-1-1 record and a 39-6 Pineapple Bowl win over the University of Hawai'i.

His 1941 team reached as high as No. 12 in the national rankings, and that vote was taken before the Beavers knocked off No. 2 Duke 20-16 on the Blue Devils' home field on January 1, 1942, to finish the season at 8-2. In 1946, Stiner's Beavers went 7-1-1. "He was the greatest guy you could ever play for," said Quentin Greenough, the center on that Rose Bowl team. "He was a great psychologist. He not only was great with fundamentals, he was great at getting a team ready to play."

Stiner captained the University of Nebraska football team and earned All-America honors. He came to Oregon State in 1928 as an instructor, track coach, and an assistant football coach on Paul Schissler's staff. When Schissler left OSC, Stiner became the head man. He left after the 1948 season, which had seen the Beavers go 5-4-3. Stiner was inducted into the State of Oregon Sports Hall of Fame in 1981 and the OSU Athletic Hall of Fame in 1990.

QUENTIN GREENOUGH, A center from San Gabriel, California, earned All-America honors as the Beavers earned their first-ever Rose Bowl berth during the 1941 season.

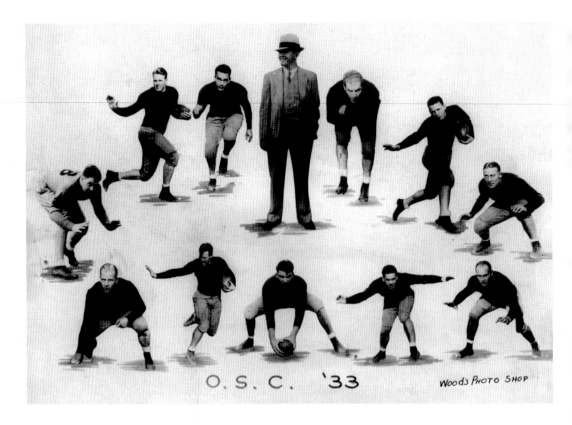

O. S. C. '33

Wood's Photo Shop

THE EQUATION "60 MINUTES by 11 men" was what Oregon State used to end USC's 25-game winning streak on October 23, 1933. The 0-0 tie at Portland's Multnomah Stadium remains one of the most storied games in school history and earned the "Iron Men" moniker for Vic Curtin, Ade Schwammel, Bill Tomscheck, Clyde Devine, Vern Wedin, Harry Field, Woody Joslin, Harold Pangle, Red Franklin, Pierre Bowman, and Harold Joslin.

"It was a dramatic and thrill packed game, this one, which broke the charm of Trojan impregnability," wrote L. H. Gregory of the *Oregonian*. "The story of it is the story of the flaming, unconquerable spirit of those 11 Oregon State boys with hearts of steel." The Trojans, meanwhile, substituted 18 times during the game that drew a crowd of 25,000.

USC drove inside the Oregon State 10-yard line twice but was stopped on downs both times, and Franklin picked off three passes inside the Beaver 20-yard line. In the fourth quarter, the Trojans appeared ready to score when Haskell Wotkyns burst through a hole over the right guard from the OSC 9-yard line, but Pangle hit him from the side with enough force to bring him down at the 7-yard line and knock him out of the game. A possession later, the Trojans' last-ditch effort was a long pass that Franklin intercepted and returned all the way to the Trojan 47-yard line on the final play of the game.

Tradition at the time called for the game ball to be presented to the winning team, and in case of a tie, there would be a coin flip. But USC captain Ford Palmer handed the ball to Curtin and said, "Take it, Vic. Your team earned it today." The USC game was the only one played without a substitution by Oregon State that year, though the Beavers substituted just once in wins over Washington State University and San Francisco University.

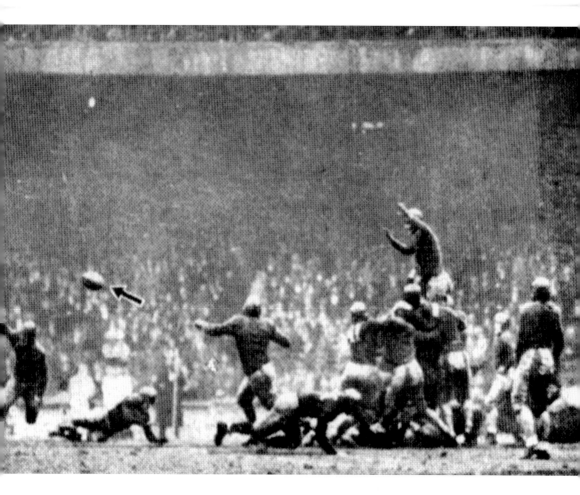

IT WAS IN THE 1933 Civil War against the University of Oregon that Oregon State's "pyramid play"— hoisting a lineman in the air to block a kick—became famous. However, it wasn't the only time the Beavers used the ploy. Later that same season, OSC's Clyde Devine is pictured here being given a boost during the Beavers' 9-6 win over Fordham at the Polo Grounds in New York; Ed Danowski's kick went wide.

Years later, as Oregon State was getting ready to play in the 1942 Rose Bowl, Stiner said the maneuver was still legal and admitted to a group of reporters that "I've toyed with the notion of trying this pick-a-back stunt for a pass receiver, but it doesn't seem practical."

Oregon State's win in front of 45,000 fans ended Fordham's Rose Bowl hopes. Noted Richards Vidmer in the *New York Herald-Tribune*, "There were few Westerners in the cheering section, but enough to tear down the goal posts after the game . . . Oregon State confined its stylish ways to the football field. After the game the players found their way back to the hotel by subway and probably found the plunging even tougher there than against the Fordham line."

OREGON STATE FOOTBALL

TEAM HUDDLE SOLVES DATE PROBLEM

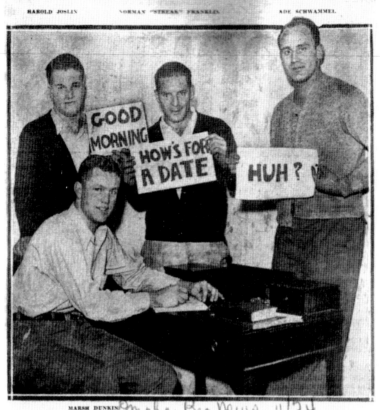

HAROLD JOSLIN NORMAN "STREAK" FRANKLIN ADE SCHWAMMEL

MARSH DUNKIN
Boys will be boys. And strange boys in a strange city will get acquainted—some way. It's just another system for Emily Post to outlaw, and it was invented by Oregon State football players staying in Fontenelle hotel. The signs are placed in a window so stenographers and filing clerks in the Finance building across the street can read and heed. They did, too, for several players already have dates.

WHEN OREGON STATE FOUND itself on a long road trip to play Fordham and Nebraska to end the 1933 season, the Beavers got a bit lonely for the fairer sex. At least it was a bit more of a sophisticated approach than scrawling "for a good time, call . . ." on a wall somewhere. OSC was billeted at the Fontenelle Hotel in Omaha prior to the Nebraska game, directly across Douglas Street from the Finance Building, which housed a fair number of female stenographers and filing clerks. How to get acquainted? Several of the Beavers obtained a heavy-duty black lead pencil and several sheets of paper and blocked out their appeal to the young ladies. Wrote the *Omaha Bee*, "The stenographers weren't to be bluffed. A big 'O.K.' appeared in one of the windows of the Finance Building. 'When?' was the next question flashed across Douglas St. by the players. '12:30' was the answer. And at 12:30 p.m. Thursday the players were grouped around the entrance to the Finance building. Two players, Harold and Woody Joslin, contacted immediately and had dates for Thursday night. For Friday night, Norman 'Streak' Franklin and Marsh Duncan, halfbacks, have dates. But there are still 26 players, girls, so there's still a chance." It is not clear how the dates turned out, but the Beavers were beaten by Nebraska 22-0 on Thanksgiving Day.

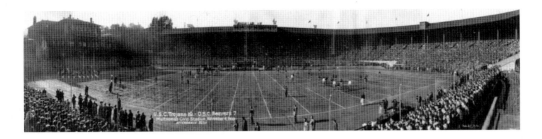

WHEN OREGON STATE AND USC got together midway through the 1939 season, a crowd of 32,711 jammed Portland's Multnomah Stadium for one of the most-anticipated games in Beaver football history. OSC was leading the race for the Pacific Coast Conference's berth in the Rose Bowl with an unbeaten record, while USC had been tied once. The Trojans were ranked No. 7 in the nation and the Beavers were ranked No. 11, and it was the first time Oregon State had played a game in which both teams were nationally ranked. Early in the week leading up to the game, Edward Morgan of *United Press* wrote, "Around the sports desks and the cigar stands, in the hotel rooms and on the streetcars—those curious places which are both the maternity wards and the restless graveyards of all football games—little rivulets of excitement already began to eddy in Portland today." By the morning of the game, oddsmakers had installed the Trojans as favorites by either 2-to-1 odds or a 13-point margin. The oddsmakers weren't far off, as USC won 19-7. The Beavers got on the board in the final minutes, which were the first points given up by the Trojans after they had blanked the University of California, the University of Illinois, and Washington State University the previous three weeks.

ORGANIZERS DID A BIT extra to make the Pineapple Bowl seem like the real thing following the 1939 season, as evidenced by the yard and down markers being held by Pineapple Bowl Queen Minerva Carroll. The game on January 1, 1940, saw the Beavers wallop host University of Hawai'i 39-6 in front of a crowd of 15,000 at Honolulu Stadium to finish 9-1-1.

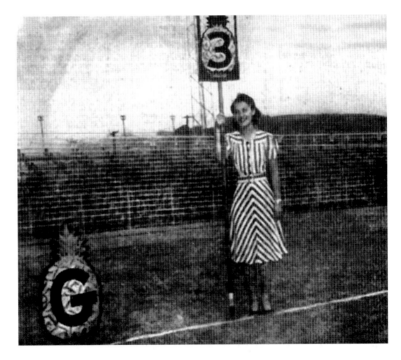

THIS IS THE GAME PROGRAM for Oregon State's first-ever appearance in the Rose Bowl, which was actually played in Durham, North Carolina, on January 1, 1942. Eight days after the Beavers beat Oregon 12-7 in Eugene, Japan attacked Pearl Harbor and World War II was underway. Less than a week later, military authorities asked that large sporting events on the West Coast be cancelled, and it seemed that OSC's long-awaited moment in the sun was not to be.

However, Duke, which the Beavers had selected to be their opponent in the game, offered to host the contest and quickly sold tickets for all 56,000 seats that it could cram into the horseshoe-shaped stadium on its campus. Oregon State hopped on a train and headed east.

Every step of the way, the Beavers received royal treatment. OSC's captain for the game, Martin Chaves, was named Mayor For A Day in Duke's home city of Durham. Covering the Rose Bowl banquet the day before the game, Frank Spencer of the *Winston-Salem Journal* wrote, "We don't believe there was a secretary of a chamber of commerce in the country who could have praised the treatment that his team received in North Carolina as well as Stiner did . . . 'I even found two of my boys trying to teach one of your beautiful North Carolina girls over at Chapel Hill to say 'sugar' instead of 'shoo-ger.'"

Well, why not be nice? The Beavers weren't supposed to be much of an obstacle for Duke. Oregon State had lost twice during the season while the Blue Devils were unbeaten and ranked second in the country. OSC was generally a 3-to-1 underdog as the game neared, which didn't sit well with Stiner. "If my kids could horse-collar Stanford (in a 10-0 win), why shouldn't they have a chance to stop the Duke scoring machine?" he asked the *New York Sun*'s George Trevor a few days before the game. "I expect them to do just that and hand the experts another stunning surprise . . . Mind you, I am not predicting victory over Duke but I do say that this Oregon State team cannot be beaten on paper. Newspaper prophets realize that by this time. The team that conquered California, Stanford and Washington figures to give a good account of itself against Duke even though we're a long way from home and may find the weather too warm."

The Beavers themselves seemed to be taking everything in stride. When they arrived in Washington, D.C., on the way to North Carolina, sports columnist Francis E. Stan observed:

> It seems safe to suggest that as far as the man on the street is concerned Oregon State is a bush team on a coast-to-coast joyride . . . From Head Coach Lon Stiner on down they did their best not to spoil an Easterner's popular impression of a team from Oregon State College along the Willamette River. They rubber-necked at the city from a sight-seeing bus, ate heartily at an evening meal and piled back onto the train for the last lap . . . Somehow, the Beavers didn't behave like a big bowl team. The schools from New York, for instance, put it on big. It's all boom-boom and don't spare the cymbals. The Texas teams take their cues from the chambers of commerce and swagger into town wearing high-heeled boots and wide white sombreros. The California outfits come in style, movie stars hamming things up and press agents beating the big drums . . . The Beavers, though, behaved normally and this was not at all usual.

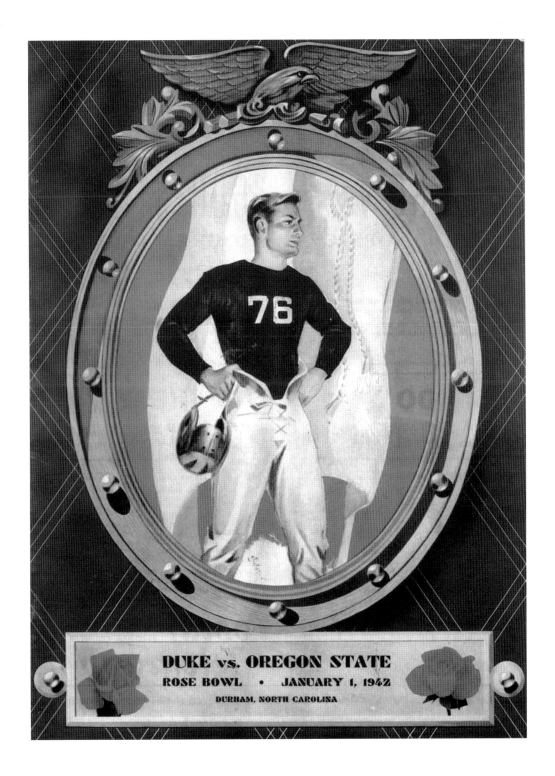

DUKE vs. OREGON STATE
ROSE BOWL • JANUARY 1, 1942
DURHAM, NORTH CAROLINA

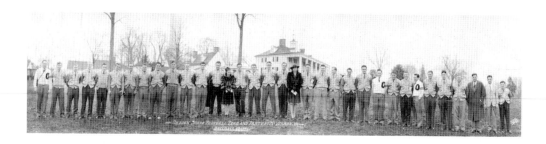

THIS TRIP TO MOUNT VERNON was just one of the stops the Beavers made during a 21-day, 7,384-mile railroad trek for the 1942 Rose Bowl. OSC's group also received polo and golf lessons at Pinehurst Country Club, saw the East-West Shrine All-Star Game in New Orleans that, similar to the Rose Bowl, had been moved from San Francisco, and stopped in Southern California to take a look at the actual Rose Bowl stadium. The Beavers left Corvallis on December 19, stopped in Chicago and Washington, D.C., for practices, and did their final week of training at the University of North Carolina.

DUKE RINGED ITS STADIUM with extra bleachers in front of and behind the permanent seats for the Rose Bowl, allowing a crowd of 56,000 to wedge its way in to see Oregon State's 20-16 victory.

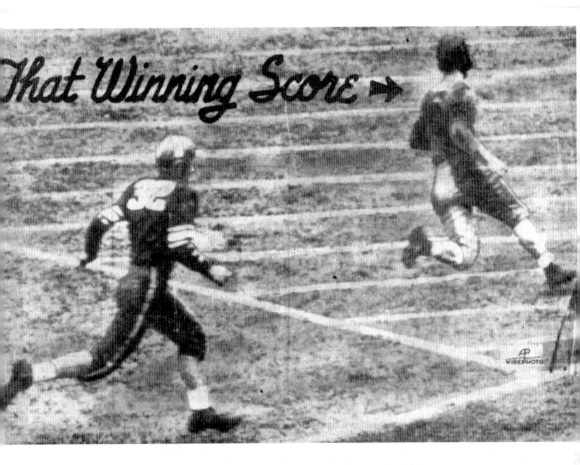

That Winning Score ➔

OREGON STATE'S GENE GRAY romps into the end zone with the winning touchdown in OSC's 20-16 win over Duke after taking a pass from Bob Dethman for a 68-yard scoring play, which gave the Beavers the lead for good at 20-14 in the third quarter. The Beavers knocked off the unbeaten, No. 2-ranked Blue Devils on their own home field when almost no one had given them a chance. Legendary sportswriter Grantland Rice reviewed the game in his nationwide column, and he gave credit to Duke's talent and record, then noted:

Against this Duke angle, Lon Stiner and his Oregon State troupers knew only the hard way. They had never before won a Rose Bowl chance. They opened their season by a defeat from Southern California. They had to battle against odds week after week. They had known no oasis in the desert of hard competition. Then Oregon State went to Durham with the odds 4-to-1 against them. I figured Duke's 1941 schedule rated Duke a 6-to-5 choice. No better. I think Maj. Swede Larson of the Navy and the Marines called the turn between halves at Durham when he said, "you can see that Duke is being hit harder and keener than at any time during the season. Duke doesn't seem to be quite used to this." That was the answer. I rode back West with the Oregon Staters. They were a strong, husky-looking bunch who gave you the idea they had been used to hard battling—and could give it and take it. They had been hit hard all season, while Duke had been on a flock of picnics, largely in soft meadows.

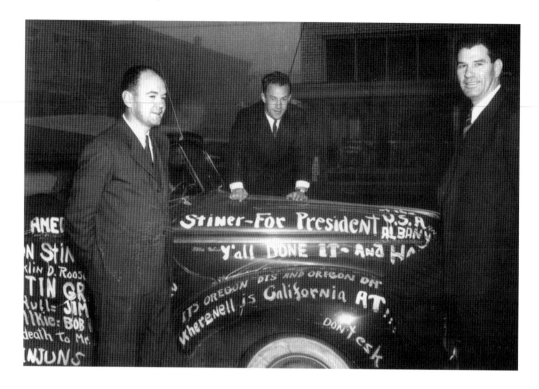

OREGON STATE GARNERING A SPOT in the Rose Bowl for the first time prompted someone to decorate a convertible. It included the endorsement, reflecting the sometimes-contentious relationship between Corvallis and Albany, on the hood that read, "Stiner—For President of the U.S.A. and Albany." OSC head coach and potential candidate Lon Stiner (left) and assistant coaches Hal Moe (center) and Jim Dixon (right) admire the work.

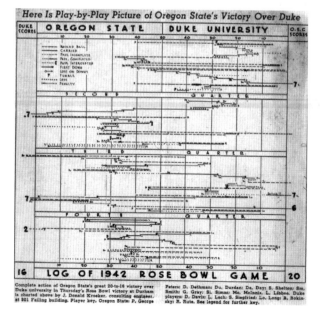

J. DONALD KROEKER, a consulting engineer, often produced these play-by-play charts of important Oregon State football games. This is how the Beavers' victory over Duke looked in Kroeker's system.

THE BEAVERS GREETING WHEN they returned to Corvallis on January 8 included this throng in front of Corvallis City Hall on the southeast corner of Fourth Street and Madison Avenue. There was also a ceremony in the men's gymnasium, and OSC classes were suspended for the day. The *Oregon Journal* reported, "From the appearance of the campus in the vicinity of Memorial Union hall and the men's gymnasium, it seemed as if the entire population of Benton county was in attendance."

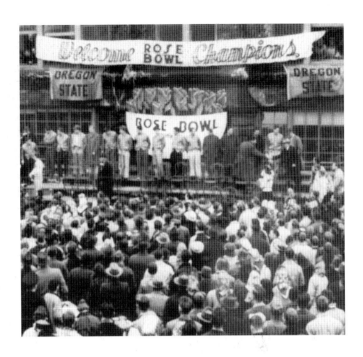

OREGON STATE'S WIN OVER DUKE led to speculation that Beaver head coach Lon Stiner might be lured away by another school; rumored to be among his potential suitors were Yale, Illinois, and Nebraska, his alma mater. In response, the state board of higher education approved a $400 raise for Stiner to a salary of $7,000 per year. It also approved an extra $2,000 paycheck for Stiner "for his labors in connection with the Rose Bowl classic," according to the *Oregon Journal.*

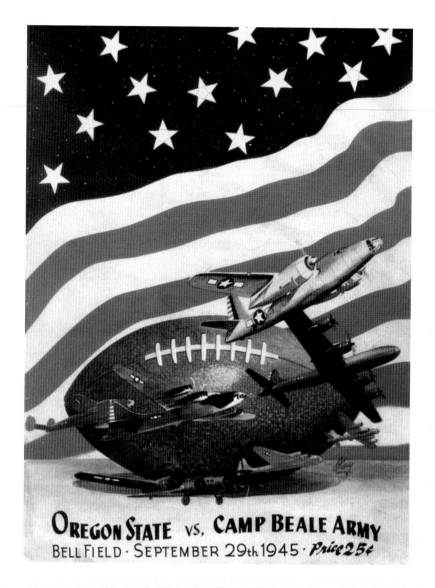

OREGON STATE vs. **CAMP BEALE ARMY**
BELL FIELD · SEPTEMBER 29th 1945 · *Price 25¢*

AFTER SHUTTING DOWN FOOTBALL for the 1943 and 1944 seasons, Oregon State resumed the sport in 1945 with a game against Camp Beale at Bell Field. The patriotic motif of the program reflects that the game was played just 45 days after V-J (Victory Over Japan) Day ended World War II. Camp Beale was no pushover, boasting 14 former college players to send against head coach Lon Stiner's young Oregon State squad, whose only returning letterman—from long-ago 1942—was fullback Bob Stevens. A crowd of 7,000 watched a 14-14 tie.

Pacific Coast Conference schools hadn't decided until June whether they'd resume their football schedules the following fall, and some wondered whether it was yet proper. In the *Oregonian*, columnist L. H. Gregory quoted a letter from U.S. Navy Hospital Apprentice Third Class Larry Budlong to Budlong's father, writing, "Sure will be glad to see the colleges resume their football; it doesn't seem the same when you read all the football news and no teams from your home state. The general opinion of everybody out here is that sports should be continued at home."

HAROLD MATTICE LETTERED JUST one year, in 1945, for Oregon State, and he was one of the first Beavers ever to wear a face mask. Given the position of the apparatus, it appears that the improvised bars on his helmet were to keep his glasses from being broken rather than to protect his face. Mattice, an end, had attended Brigham Young before going into the service. When he returned to school, he was in Oregon State's starting lineup for the first two games of the 1945 season.

IT IS THE SUMMER OF 1946 and Bell Field, seen here from the men's gymnasium (now Langton Hall), is getting a drink in anticipation of the coming season. That same year, Bell Field saw about the best results possible as Oregon State didn't surrender a point on its home turf during the season, beating Vanport College (Portland State University) 35-0, tying Stanford University 0-0, beating the University of Idaho 34-0, and knocking off Oregon 13-0. Overall the Beavers recorded one of their best-ever seasons, going 7-1-1.

OREGON STATE'S CARLOS HOUCK drags down Michigan State University's Lynn Chandnois as OSC teammates Stan McGuire (No. 85) and Tom De Sylvia (No. 69) close in. It is November 12, 1949, and Oregon State is upsetting the No. 8-ranked Spartans 25-20 before 22,239 fans at Portland's Multnomah Stadium.

OREGON STATE END STAN MCGUIRE hauls in a pass from Ken Carpenter in the Beavers' 25-20 win over the Spartans in 1949. For a performance that included a touchdown catch, a field goal, a safety on a blocked punt, and three point-after kicks, McGuire, a graduate of Roosevelt High School in Portland, Oregon, was named National Lineman of the Week by the *Associated Press*. The next week, the Beavers won 20-10 at Oregon, prompting McGuire to tell reporters, "It's always great to win, particularly when the losing team is Oregon." McGuire was named one of Oregon State's captains for 1950 but was killed in a car accident prior to the season.

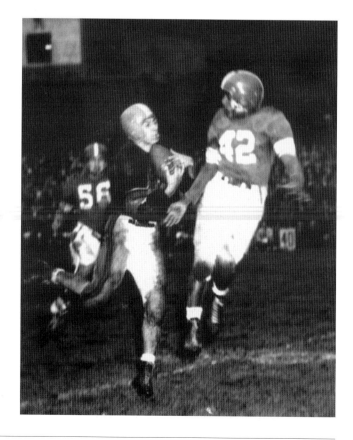

OREGON STATE QUARTERBACK Gene Morrow passes against the University of Idaho in a 34-19 win at Bell Field on November 11, 1950. From The Dalles, Oregon, Morrow lettered at OSC from 1949 through 1951 and played in the Canadian Football League but went on to greater accomplishment as one of the winningest high school football coaches ever in Oregon. From 1955 through 1999 at Newport High School, Morrow's teams were 276-153-4.

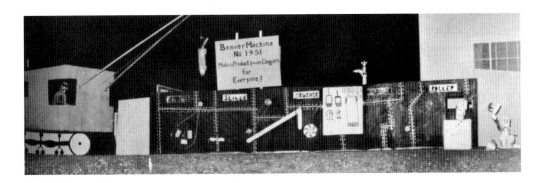

OREGON STATE'S CHAPTER of the Kappa Delta Rho fraternity went the elaborate route with its 1951 entry in the homecoming sign competition, building a mechanized display honoring Beaver Machine No. 1951. Alas, there was a malfunction as OSC lost to Washington State University 26-13 at Bell Field.

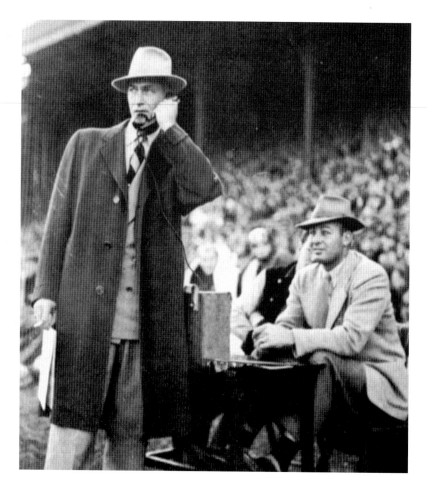

OREGON STATE HEAD COACH Kip Taylor confers with an assistant in the press box during a 1951 game at Bell Field. Taylor coached the Beavers from 1949 through 1954, compiling a 20-36 record. Taylor's first team went 7-3, including a 25-20 upset over No. 8-ranked Michigan State in Portland. The 1951 Beavers moved into the national polls that season after a 6-0 loss at No. 2-ranked Michigan State and a 61-28 win over the University of Utah. OSC also opened Parker Stadium in 1953, beating Washington State 7-0 in its debut. Taylor had a knack for beating Oregon, as his teams won their first five Civil War games. However his first loss to Oregon, by a 33-14 score in Corvallis, ended a 1-8 campaign in 1954, and he resigned shortly thereafter. Less than a month later, Oregon State president A. L. Strand pondered the state of intercollegiate athletics in the *Oregon Stater* alumni magazine. He ruminated on the near impossibility of colleges caught up in big-time sports to scale back their commitments and on how a school's dependence on the Pacific Coast Conference's Rose Bowl and television revenue would be a factor in it. Wrote Strand, "The upshot is that we try to compete in a league where the division of talent is very uneven and competition is very tough. It is to be expected that there will be periods of frustration. Very unfortunately and often unjustly the coaching personnel receives the brunt of these reactions." Taylor had played collegiately at the University of Michigan, where he scored the first touchdown ever at Michigan Stadium.

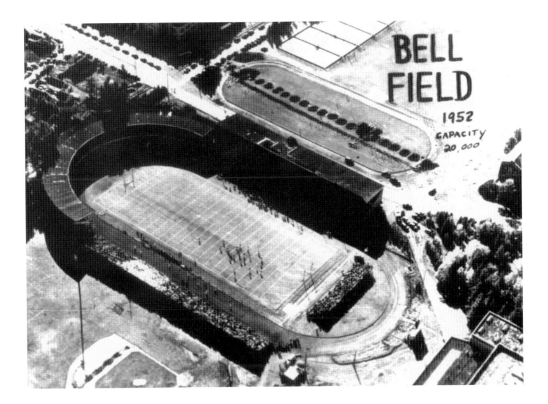

BELL
FIELD
1952
CAPACITY
20,000

IN 1952, BELL FIELD was in its final football season. It was named after Dr. J. R. N. "Doc" Bell, one of Oregon State's staunchest supporters during the first half of the 20th century. The first stands went up in 1913 as a 3,000-seat wooden bleacher on the east sideline. In 1920, a covered grandstand of steel, concrete, and wood was added on the west sideline to increase capacity to 7,000. Four years later, the double-decked horseshoe encircling the south end of the field was added, giving Bell Field 18,000 seats. In 1947, the east stands were replaced by bleachers, bringing capacity to roughly 21,000. Oregon State continued to use Bell Field as its track and field home through 1974, with several thousand uncovered seats along the west side. Dixon Recreation Center now stands on the site.

WHEN OREGON STATE'S NEW FOOTBALL stadium was designed in the early 1950s, the plans allowed for an expansion to 50,000 seats or more. This drawing visualizes the eventual layout and is an approximation of how the west sideline looked by 1991. The 40 rows and exit tunnels were added for the 1967 season, and an overhang—though not as expansive as the one pictured here—was in place by 1991.

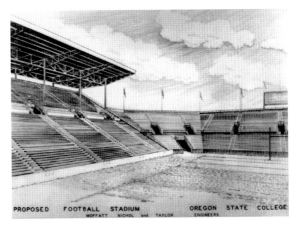

PROPOSED FOOTBALL STADIUM — MOFFATT NICHOL and TAYLOR — OREGON STATE COLLEGE ENGINEERS

OREGON STATE FOOTBALL

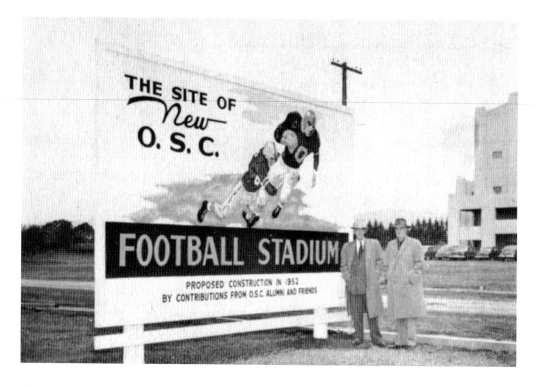

OREGON STATE PRESIDENT A. L. Strand, left, and athletic director Roy "Spec" Keene look over the site of the school's soon-to-be built football stadium in early 1953. They're just across the street from Gill Coliseum, which opened in the winter of 1949–1950.

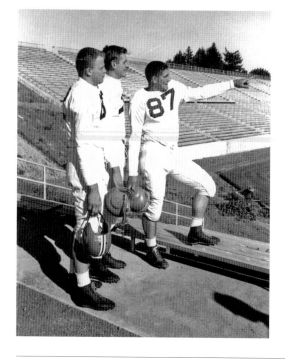

OREGON STATE END WES EDIGER points out the features of new Parker Stadium to teammates in 1953. Ediger had a big role on the stadium's opening day, catching a 44-yard pass from Jim Withrow to set up the game's only score in a 7-0 win over Washington State. Appropriately the citizens of Ediger's nearby hometown of Dallas, Oregon, had declared it "Wes Ediger Day" and approximately 500 of them saw him play in the new stadium's first game.

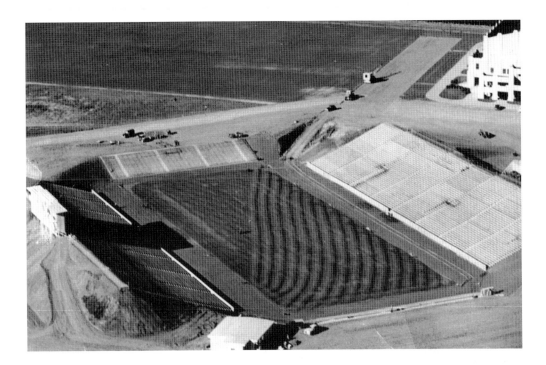

PARKER STADIUM WAS ORIGINALLY 42 rows on each sideline, 18 rows in the north end, 15 rows in the south end, concession/restroom buildings in each corner, and a two-story press box. The stadium cost $300,000 and was named for Portland contractor and OSC alumnus Charles T. Parker, who had a significant role in the fund-raising and construction.

THE NAME OF OREGON STATE'S new stadium wasn't clear when it opened on November 14, 1953. The game program says Parker Field, even though it became known as Parker Stadium through 1998. The new concrete structure seated 22,000 fans and was ready for the final home game of 1953. The Beavers were just 1-6 as they opened their new home against Washington State. Chuck Brackett's one-yard touchdown plunge in the second quarter gave Oregon State a 7-0 win in front of approximately 13,500 homecoming fans.

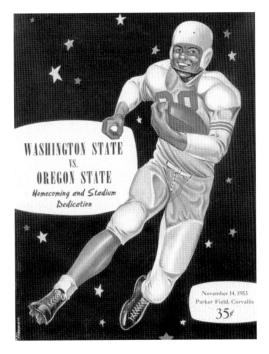

WASHINGTON STATE
VS.
OREGON STATE
Homecoming and Stadium
Dedication

November 14, 1953
Parker Field, Corvallis
35¢

ALL-AMERICAN JOHN WITTE OF OSC MEETS OTHER COLLIER'S MAGAZINE ALL-AMERICANS
AT LATIN QUARTER IN NEW YORK CITY, 1956

JIM BROWN	JOHN WITTE	JOHNNY MAJORS	RON KRAMER	JIM PARKER
Syracuse Fullback	OSC Tackle	Tennessee Tailback	Michigan End	Ohio State Guard

THE 1956 FOOTBALL SEASON ENDED, and *Collier's* magazine invited members of its All-America team to New York City. Among this group that got together for an evening at the Latin Quarter is Oregon State tackle John Witte, the Beavers' first two-time All-American. From Klamath Falls, Oregon, Witte earned a number of honors in 1955 and was then a consensus pick in 1956 as the Beavers won the Pacific Coast Conference title with a 7-2-1 record and earned a trip to the Rose Bowl. Witte is in the midst of some pretty fast company, football-wise, though no one may have known just how fast at the time.

Syracuse fullback Jim Brown went on to be one of the finest running backs in professional football history for the Cleveland Browns, rushing for 12,312 yards and 106 touchdowns in his eight seasons. University of Tennessee tailback Johnny Majors became better known for his coaching, including leading Pittsburgh to the 1976 national championship and then at Tennessee from 1977 through 1992, where he posted a 116-62-8 record. University of Michigan end Ron Kramer played for the Green Bay Packers' championship teams in 1961 and 1962 and had a 10-year career in the National Football League. The Ohio State University guard Jim Parker went on to earn All-Pro status with the Baltimore Colts for eight straight seasons, becoming the first man to play purely offensive line to be elected to the Pro Football Hall of Fame. Brown, Majors, Kramer, and Parker all went on to be inducted into the College Football Hall of Fame.

Witte, who also placed second in the NCAA wrestling championships at heavyweight as a freshman, played one season in the Canadian Football League for the Saskatchewan Roughriders. He went on to a career as an educator in the Portland schools, including many years at Jefferson High School, and authored several children's books.

1933–1954

1955−1975

AFTER SOME DOWN seasons, it didn't take long for Oregon State to bounce back when Tommy Prothro was hired as head coach. The next 15 years were some of the best in the Beavers' football history as conference titles, bowl games, and All-Americans were frequent occurrences under Prothro and his successor, Dee Andros. The sport attracted crowds that forced the expansion of Parker Stadium to a capacity of roughly 40,000 for the 1967 season. Within five years, though, the Beavers had begun a long-term struggle just to regain respectability.

THE COACHES: Tommy Prothro, 1955–1964; Dee Andros, 1965–1975.

THE ALL-AMERICANS: John Witte, tackle, 1955–1956; Ted Bates, offensive tackle, 1958; Terry Baker, quarterback, 1962; Vern Burke, split end, 1963; Jack O'Billovich, linebacker, 1964; Rich Koeper, offensive tackle, 1964; Jess Lewis, defensive tackle, 1967; Jon Sandstrom, guard, 1967; John Didion, center, 1967; Bill Enyart, fullback, 1968; Craig Hanneman, defensive tackle, 1970; Steve Brown, linebacker, 1972.

THE GOLDEN YEARS: In 1956, 7-3-1 record, Rose Bowl loss, and ranked as high as No. 11; in 1957, 8-2 record, conference cochamps, and ranked as high as No. 7; in 1962, 9-2 record, Liberty Bowl win, Terry Baker wins Heisman Trophy, and ranked as high as No. 17; in 1964, 8-3 record, Rose Bowl loss, and ranked as high as No. 8; in 1967, 7-2-1 record, "Giant Killers" beat No. 2 Purdue, tied No. 2 UCLA, beat No. 1 Southern California, and ranked as high as No. 8.

THE WAIT-'TIL-NEXT-YEARS: In 1959, 3-7 record; in 1972, 2-9 record; in 1973, 2-9 record; and in 1975, 1-10 record.

THE BEST OF TIMES: In 1957, beat No. 15 Oregon 10-7 in Eugene for share of conference title; in 1960, beat No. 6 Southern California 14-0 in Portland; in 1962, beat No. 19 West Virginia 51-22 in Portland, beat Villanova University 6-0 in Liberty Bowl; in 1964, beat No. 17 Oregon 7-6 in Corvallis; in 1967, beat No. 2 Purdue in West Lafayette, Indiana, tied No. 2 UCLA 16-16 in Los Angeles, California, beat No. 1 Southern California 3-0 in Corvallis; in 1970, beat No. 14 Oklahoma 23-14 in Norman, Oklahoma; and in 1971, beat No. 11 Arizona State 24-18 in Portland.

ALL DRESSED UP WITH someplace to go, Oregon State players board their flight to Pasadena for the 1957 Rose Bowl against the University of Iowa. It was the Beavers' first-ever trip to play in the Southern California stadium of the same name. The Beavers arrived in time to celebrate Christmas at the Miramar Hotel in Santa Monica. Among the guests was NBC announcer Mel Allen, who told *Associated Press* reporter Hal Laman, "You know, if the critics of football could sit in on parties like this, they'd soon have a change of mind about the so-called boneheads that play this game."

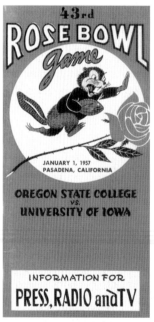

43rd
ROSE BOWL
game

JANUARY 1, 1957
PASADENA, CALIFORNIA

OREGON STATE COLLEGE
vs.
UNIVERSITY OF IOWA

INFORMATION FOR
PRESS, RADIO and TV

OREGON STATE WAS READY FOR the scrutiny of reporters when it went to Southern California for the 1957 Rose Bowl (above left), and the Beavers also got some attention from the political world. Los Angeles mayor Norris Poulson, a native of Baker, Oregon, who attended Oregon State, told the Beavers, "We'll whip those guys from Iowa." Among the Beavers' stops in Southern California prior to the Rose Bowl was Disneyland, which had opened just over a year before. Tackle Ted Bates (above right) and back John Owings consider taking a ride.

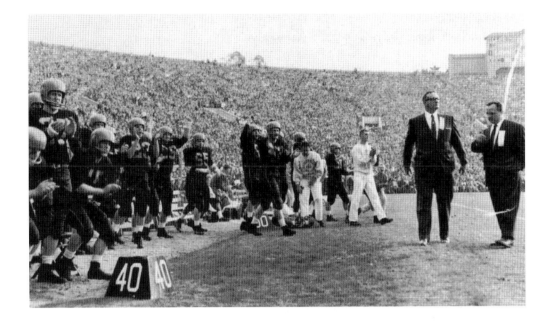

THESE 100,000 FANS in the background saw No. 10-ranked Oregon State victimized by some early mistakes, and the Beavers lost 35-19 to No. 3-ranked Iowa in the Rose Bowl on January 1, 1957. OSC head coach Tommy Prothro, second from right, and the Beavers already had one crack at Iowa, losing to the Hawkeyes 14-13 on Iowa's home field in early October; it was the first Rose Bowl to pair teams that had already played during the regular season. Wrote George Pasero of the *Oregon Journal* after talking to the Beavers after the game, "All the opinions ended up at the same place. OSC tackling was the worst of the season and no one seemed able to explain why."

OREGON STATE HALFBACK JOE Francis is dragged down during the 1957 Rose Bowl. From Honolulu, Hawai'i, Francis rushed for 73 yards and passed for another 130 yards, but the Beavers were beaten by Iowa 35-19.

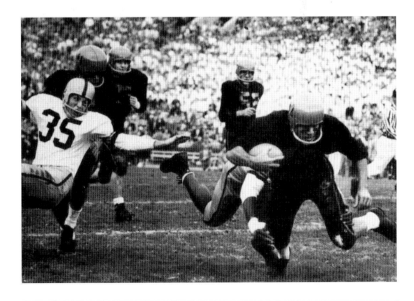

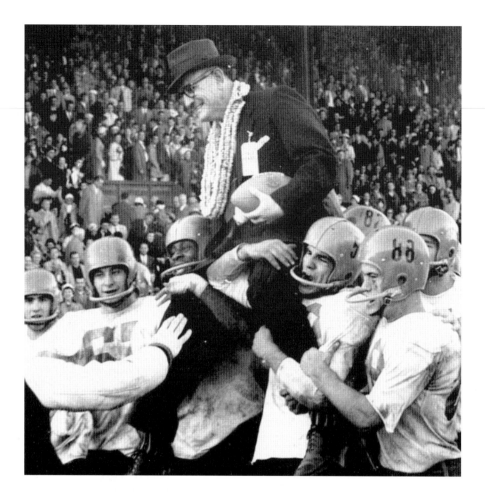

OREGON STATE WOULDN'T be going to the Rose Bowl, but the Beavers had plenty of reasons to celebrate after they won the 1957 Civil War, and the exuberance following a 10-7 victory included a postgame ride for head coach Tommy Prothro.

As the 1957 season drew to a close, Oregon State was in the running for the Pacific Coast Conference championship, but the Beavers knew they wouldn't be going to the Rose Bowl as the conference had a no-repeat rule at that point prohibiting a school from playing in the game in back-to-back seasons. Still when it came down to the Civil War, the Beavers had a chance to share the Pacific Coast Conference title with Oregon if they could beat the Ducks in Eugene. And in Oregon State's mind, a win over their in-state rivals would give them a leg up on the lemon-and-yellow because of bragging rights for the year and ownership of a better overall record.

A crowd of 23,150 packed Hayward Field knowing that Oregon would be headed for Pasadena. Oregon State took a 7-0 lead when Joe Francis's three-yard off-tackle run and Ted Searle's extra point capped a 69-yard drive in the first quarter. Oregon answered later in the quarter to tie the game at 7-7. Searle knocked through a 17-yard field goal in the third quarter, though, and the Beavers held off the Ducks the rest of the way to secure the win. Francis finished with 76 yards on 17 carries as Oregon State earned at least a share of the conference championship for the second straight year.

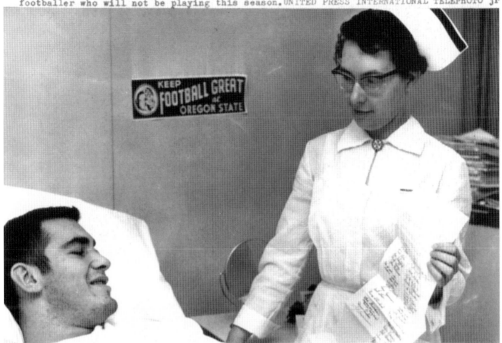

BUZZ RANDALL WAS AN ALL-PACIFIC Coast center for Oregon State in 1957, and he'd played on the 1956 team that reached the Rose Bowl. The senior from Estacada, Oregon, was elected one of the Beavers' cocaptains for 1958, but he died of leukemia on September 20, 1958, one day after OSC opened the season with a 21-0 loss at USC. The sports section of the 1959 *Beaver* yearbook's dedication to Randall read, in part, "Not aggressive in personality, he was personable. While others may have dominated the conversation, Buzz always knew when to speak, and it was always in a modest, unassuming vein . . . Even in the months of his fatal illness, Buzz demonstrated the same courage that he did on the football field."

OREGON STATE'S 1958 MEDIA GUIDE trumpeted the accomplishments of Tommy Prothro's first three seasons as head coach. Ted Bates, a big tackle from Los Angeles, was an All-America candidate and a consensus pick to postseason all-star teams, earning the Hayward Award as the top amateur athlete in Oregon. He played four seasons for the Chicago/St. Louis Cardinals in the NFL, and he was inducted into the State of Oregon Sports Hall of Fame in 1996.

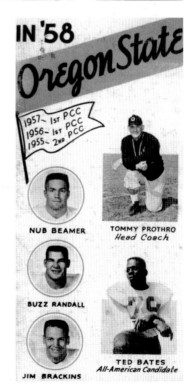

TOMMY PROTHRO, on OSU's sideline in the early 1960s (opposite, fourth from left), was the last head coach at Oregon State to wear a fedora on the sideline and the last head coach in the 20th century to take the Beavers to the Rose Bowl. Prothro was at Oregon State from 1955 through 1964, with his teams going 63-37-2 with a pair of trips to the Rose Bowl and another to the Liberty Bowl. More success at UCLA later in his career helped land him in the College Football Hall of Fame in 1991.

Prothro took the Beavers from a 1-8 record the season before he arrived and immediately guided them to a 6-3 record and second place in the Pacific Coast Conference in 1955. The next season, the Beavers were 7-3-1 and in the Rose Bowl, where they lost to Iowa 35-19. Oregon State earned a share of the Pacific Coast Conference title again the next season and beat cochampion Oregon 10-7, but the conference had a no-repeat rule that barred the Beavers from returning to Pasadena.

After the Pacific Coast Conference disbanded, the Beavers played an independent schedule from 1959 through 1963. In 1962, OSU went 9-2, quarterback Terry Baker won the Heisman Trophy, and the Beavers beat Villanova 6-0 in the Liberty Bowl. With Oregon State back in the conference in 1964, the Beavers earned the Rose Bowl berth but lost to the University of Michigan 34-7. In the final rankings, his teams had been No. 19 in 1957, No. 17 in 1962, and No. 8 in 1964. "He was unique in that he took teams to the Rose Bowl with two entirely different systems (the Single Wing and the T formation)," Rich Brooks told the *Oregonian*; Brooks played for Prothro and then coached under him for a year at OSU before going on to be head coach at Oregon and the University of Kentucky and with the National Football League's St. Louis Rams. "The stature of the man, the fundamentals and the system all were a part of it . . . what he accomplished at Oregon State was truly amazing." Prothro left for UCLA after the 1964 season and eventually was a head coach in the NFL for the Los Angeles Rams and San Diego Chargers.

Prothro had lived in Oregon as a child, and his father, James Thompson "Doc" Prothro, played third base for the Portland Beavers in 1926 and 1927. Tommy Prothro played for Duke in its 1942 Rose Bowl loss to Oregon State, and upon his arrival in Corvallis, Prothro wryly noted, "I know that Oregon State can play good football. I know because I played against a good Oregon State team myself."

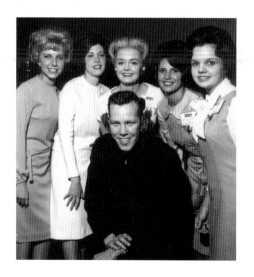

VERN BURKE, AN END from Bakersfield, California, is greeted by the queens of the Bluebonnet, Gator, Orange, Cotton, and Sugar bowls at a gathering for *Look* magazine's 1963 All-America team in New York City. The earmuffs referenced the previous season's frigid Liberty Bowl and were given to Burke as a consolation prize for the Beavers not returning to a bowl game.

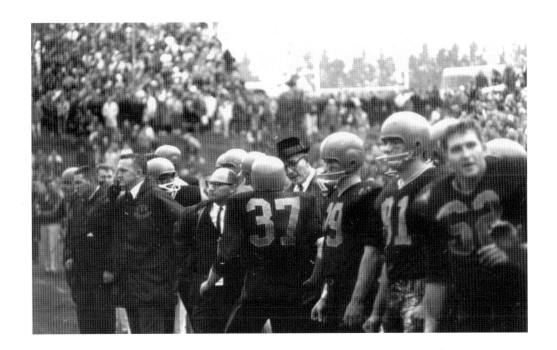

OREGON STATE HONORED TERRY BAKER by retiring jersey No. 11, which he wore while winning the Heisman Trophy in 1962. As a sophomore in 1960, though, Baker sported No. 47. The all-around athlete from Jefferson High School in Portland, Oregon, hadn't played football as a freshman, concentrating on basketball and baseball. But OSU head coach Tommy Prothro used a stretch of wet, baseball-unfriendly weather to invite Baker to spring football practice. Prothro listed Baker as the No. 2 tailback, and when Baker saw that on the depth chart, it prompted his return to the sport.

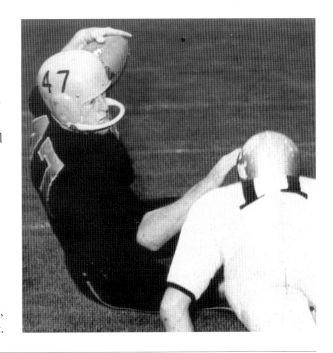

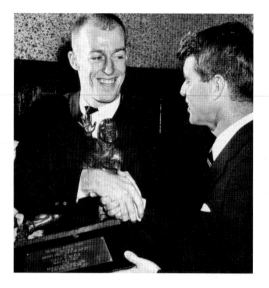

WITH A BOWL WIN, a Heisman Trophy, and a Final Four men's basketball team, 1962–1963 was a bit like Camelot for Oregon State; the men's track team also finished sixth nationally and the baseball team was one game from the College World Series. It was appropriate that a member of Pres. John F. Kennedy's "Camelot" presented Baker his Heisman Trophy. Attorney general Robert Kennedy did the honors at the New York Athletic Club on December 5. A reserve on Harvard's 1947 team, Kennedy quipped, "I was a short end. I think the Heisman committee should recognize good, short substitutes."

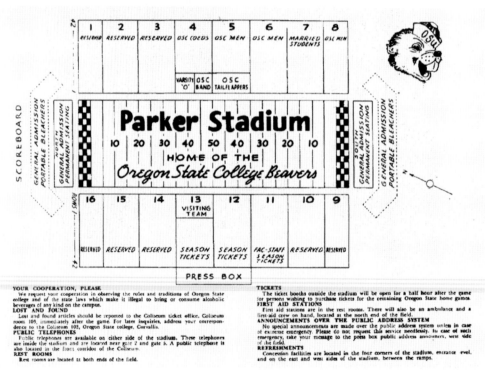

YOUR COOPERATION, PLEASE
 We request your cooperation in observing the rules and traditions of Oregon State college and of the state laws which make it illegal to bring or consume alcoholic beverages of any kind on the campus.
LOST AND FOUND
 Lost and found articles should be reported to the Coliseum ticket office, Coliseum room 105, immediately after the game. For later inquiries, address your correspondence to the Coliseum 103, Oregon State college, Corvallis.
PUBLIC TELEPHONES
 Public telephones are available on either side of the stadium. These telephones are inside the stadium and are located near gate 2 and gate 5. A public telephone is also located in the front corridor of the Coliseum.
REST ROOMS
 Rest rooms are located at both ends of the field.

TICKETS
 The ticket booths outside the stadium will be open for a half hour after the game for persons wishing to purchase tickets for the remaining Oregon State home games.
FIRST AID STATIONS
 First aid stations are in the rest rooms. There will also be an ambulance and a first-aid crew on hand, located at the north end of the field.
ANNOUNCEMENTS OVER THE PUBLIC ADDRESS SYSTEM
 No special announcements are made over the public address system unless in case of extreme emergency. Please do not request this service needlessly. In case of such emergency, take your message to the press box public address announcer, west side of the field.
REFRESHMENTS
 Concession facilities are located in the four corners of the stadium, entrance level, and on the east and west sides of the stadium, between the ramps.

THE PARKER STADIUM SEATING MAP used in 1962 may have been a little out of date, since it is labeled as the home of "Oregon State College" rather than Oregon State University—the school's name changed on March 6, 1961. Even so, it is worth noting the seating arrangements in the east grandstand, where the student section is divided into blocks for coeds, men, and married students; for many years it was against Oregon State tradition to sit with a date at a football game or any other sporting event.

1955–1975

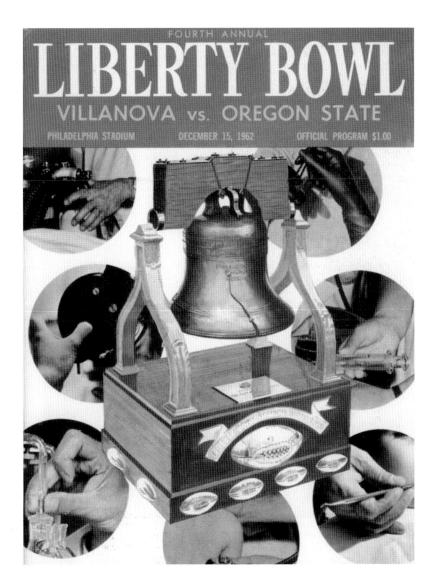

FOURTH ANNUAL

LIBERTY BOWL

VILLANOVA vs. OREGON STATE

PHILADELPHIA STADIUM DECEMBER 15, 1962 OFFICIAL PROGRAM $1.00

THERE WEREN'T MANY PEOPLE on hand to buy this program for the 1962 Liberty Bowl at Philadelphia's Municipal Stadium. With a temperature of 17 degrees at kickoff, only 17,048 fans made their way to the enormous arena on the south side to see the No. 17-ranked Beavers beat hometown Villanova 6-0. Wrote George Pasero of the *Oregon Journal*, "The Liberty Bowl was televised, of course, with an estimated audience of 27 million in saloons and living rooms a lot more comfortable than the 17,048 human ice cakes who attended." The only score came on Terry Baker's 99-yard run with 9:54 left in the first quarter, and Oregon State spent the rest of the afternoon holding off the Wildcats. OSU's undersized "Light Brigade" line was pushed around between the 20-yard lines, and Villanova outgained the Beavers 309-299, but Oregon State came up with four fumbles and two interceptions. The medical theme of the cover photographs was in honor of the Delaware Valley Hospital Council, a beneficiary of the game.

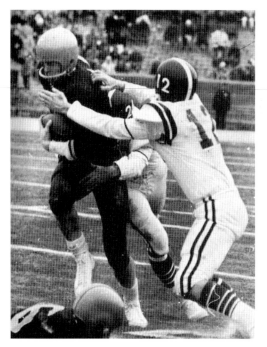

TERRY BAKER WASN'T ALL of Oregon State's offense in the 1962 Liberty Bowl, but he was close. Baker rushed for 137 yards, passed for 123, and scored the only points of the game on a 99-yard run for the 6-0 win. Said Baker, "They were trying to blow us back (for a safety), so I called (play number) 111 trying to go outside." Baker swept left, escaped a tackle in the end zone, kept his feet, picked up blockers at about the 25-yard line, and cruised all the way to the end zone. Said OSU head coach Tommy Prothro, "No, Terry's not just the best college player I've ever coached. He's the best I've ever seen so far. And there isn't a close second."

WITH THE TEMPERATURE 17 DEGREES at kickoff and the field frozen, both Oregon State and Villanova switched from cleats to tennis shoes for the Liberty Bowl on December 15, 1962. The footing benefited the Beavers here, as defenders Paul Seale (No. 82), Fred Jones (No. 84), and Jim Funston (No. 72), rush in to help George Gnoss (No. 61) and Rich Brooks (No. 14).

1955–1975

BY THE EARLY 1960s, Oregon State's success meant the first expansion of Parker Stadium. Large bleachers behind the end zones raised capacity to about 28,000. After the Rose Bowl season of 1964, three corners were turned into concrete seating and an even larger bleacher was erected beyond the north end zone, bringing capacity to approximately 33,000.

OREGON STATE HEAD COACH Tommy Prothro addresses the Beavers at the 1962 football banquet in the basement of the Towne House Restaurant and Motor Inn. The young man seated at the main floor table nearest the podium, on the left side, appears to be Rich Brooks, who would go on to be an assistant coach at Oregon State, head coach at Oregon and Kentucky, and with the St. Louis Rams of the National Football League.

OREGON STATE

Parker Stadium

CORVALLIS, OREGON

Sat., Nov. 21

1:30 P.M.

**Official
Program
50c**

OREGON

THE FIRST TIME OREGON STATE and Oregon played with Rose Bowl implications for both teams was in 1964, and a crowd of 30,154 wedged its way into Parker Stadium to see the 68th Civil War. Both the Beavers and the Ducks had a chance to play in Pasadena, as OSU entered the game with a 7-2 record and No. 17 Oregon was 7-1-1. The Beavers won 7-6, scoring on Booker Washington's one-yard run with 57 seconds left—it was the only touchdown of his OSU career. Steve Clark added the extra point for the Beavers and that proved the difference, because in the second quarter Oregon State's Al East blocked Herm Meister's kick. Just inside the cover was one of the standard attractions of game programs of the era, a cartoon featuring an early version of Benny Beaver and the mascot of the opposing team.

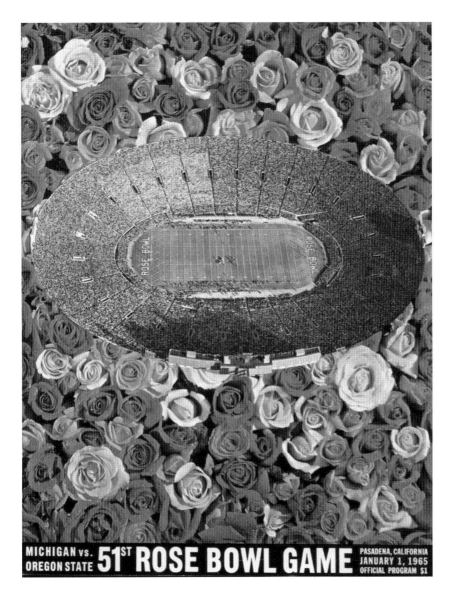

MICHIGAN vs. OREGON STATE **51**ST **ROSE BOWL GAME** PASADENA, CALIFORNIA JANUARY 1, 1965 OFFICIAL PROGRAM $1

DESPITE THIS VISUAL EVIDENCE to the contrary, the Rose Bowl can be anything but a bed of roses. Oregon State found that out on January 1, 1965, losing to the University of Michigan 34-7. The No. 8-ranked Beavers went into the game as 11-point underdogs to the No. 4-ranked Wolverines, but OSU did go into the game with some optimism. "We can win if we play our best. They're beatable," OSU linebacker Jack O'Billovich said. As for Beaver head coach Tommy Prothro, he surmised, "How do I feel about being an underdog? Well, I'd rather be a 30- to 50-point favorite." Early on, Oregon State looked like it might pull off a stunner. After a scoreless first quarter, the Beavers took a 7-0 lead, but Michigan led 12-7 at halftime and it just got worse from there. Wrote George Pasero in the *Oregon Journal*, "If this Big Ten champion team isn't number 1 in the nation, it may be only because Alabama has its own special province of the nation and doesn't venture forth to battle anyone north of Arkansas."

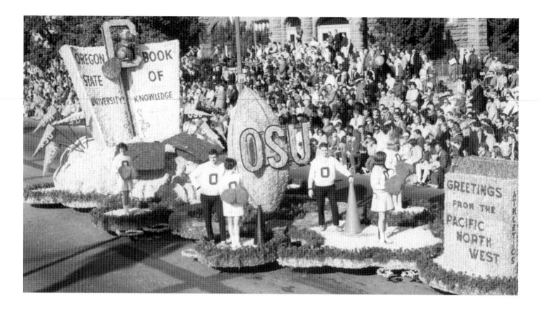

THERE'S AT LEAST A CHANCE that those on the Oregon State University float, and the dignitaries from OSU and the state of Oregon, heard some booing along the route of the 1965 Rose Parade. When OSU and Oregon rejoined the Athletic Association of Western Universities (AAWU) for the 1964 football season, schools didn't have time to juggle their schedules for a full round-robin slate of conference games. When the Beavers and the University of Southern California both finished with 3-1 records in AAWU play, the selection of the Rose Bowl representative was left up to a vote of the conference's faculty athletic representatives with OSU owning an 8-2 overall mark to USC's 7-3. The decision didn't sit well with many in and around Los Angeles, and the Beavers took quite a bit of grief from the press and public during their visit, including being booed when they were introduced prior to a Los Angeles Lakers basketball game.

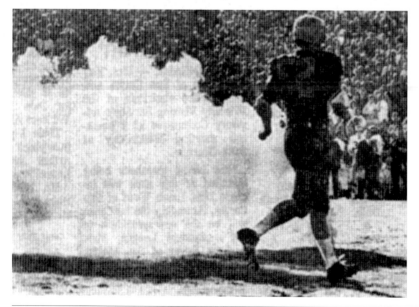

A SMOKE BOMB DELAYED play in the first half of the Beavers' 34-7 loss to Michigan in the 1965 Rose Bowl. This is Oregon State center Hoyt Keeney walking away from the cloud.

1955–1975

THERE WERE 100,423 FANS on hand for the Rose Bowl on January 1, 1965, and the ones backing Oregon State didn't have much to cheer in the loss to Michigan. Said OSU head coach Tommy Prothro, "Unfortunately, when two champions meet, one has to lose. We had a good season. I'm disappointed that it had to end on this note of disappointment." Not long after, Prothro left Oregon State to become head coach at UCLA.

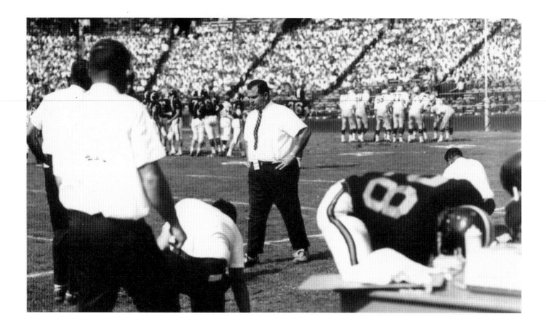

THERE'S A REASON THAT DEE ANDROS isn't looking too happy. It is September 5, 1965, and the Beavers are in the process of losing to Iowa 27-7 before 24,778 at Portland's Multnomah Stadium. It was just Andros's second game at OSU and his first "home" game before making his Corvallis debut a month later. Oregon State won at the University of Illinois 12-10 in its opener, but the loss to the Hawkeyes started a three-game losing streak. The Beavers bounced back to win four of their last six, though, and finished 5-5.

Jack (Mad Dog) O'Billovich
Oregon State

OREGON STATE'S JACK O'BILLOVICH was a returning All-American when he graced the cover of the 1965 NCAA *Football Record Book*. O'Billovich, a linebacker from Butte, Montana, nicknamed "Mad Dog" for his intense style of play, was coming off a standout 1964 season. O'Billovich was a cocaptain in 1965 for coach Dee Andros's first team, earning All-Pacific-8 honors and spots in the Hula Bowl and East-West Shrine all-star games. He went on to play in the Canadian Football League (CFL). His son Tony O'Billovich also played linebacker for the Beavers in the early 1990s and went on as well to play in the CFL.

Great Alumni Tradition . . .

Football tradition is rich at OSU, and it carries right over into alumni ranks. One of most popular events each year is spring game, matching alums against varsity. Many professional stars return, such as Heisman Trophy winner Terry Baker (Los Angeles Rams), kicking star Sam Baker (Philadelphia Eagles) and ace receiver Aaron Thomas (New York Giants). They are shown at left.

THIS PAGE FROM AN OREGON STATE recruiting book from the 1960s spotlighted three former Beavers in the National Football League ranks who returned for the annual alumni game one spring: Quarterback Terry Baker, No. 11; fullback/place-kicker Sam Baker, No. 36; and receiver Aaron Thomas, No. 89. Terry Baker played for the National Football League's (NFL) Los Angeles Rams and then the Edmonton Eskimos of the Canadian Football League from 1963 through 1967; Sam Baker, from Corvallis, Oregon, played for the NFL's Washington Redskins, Cleveland Browns, Dallas Cowboys, and Philadelphia Eagles from 1953 through 1969; and Aaron Thomas, from Weed, California, played for the NFL's San Francisco 49ers and New York Giants from 1961 through 1970. Thomas's son Robb later starred as a wide receiver at Oregon State from 1985 through 1988 and spent 10 seasons in the NFL.

ONE OF DEE ANDROS'S TRADEMARKS at Oregon State was leading the Beavers' pregame charge onto the field, generally after a rousing locker room talk. It was featured on the program for the 1967 season opener, a 13-7 win over Stanford in Portland. Former Andros assistant Ed Knecht once recalled, "The coaches who had to be up in the press box would have side bets on how well they'd be motivated when they came down on the field. And believe me, when you saw them coming down that ramp and Dee was leading them onto that field . . . they were wild-eyed, slobbering, and blowin' snot. They were ready."

OREGON STATE vs. STANFORD
Saturday, Sept. 16, 1967
8:00 p.m. – Portland Civic Stadium

Program Illustrative

50¢

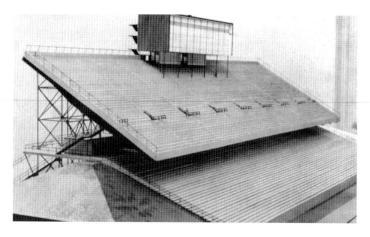

WITH THE BEAVERS coming off a Rose Bowl appearance after the 1964 season, discussion for the first large-scale expansion of Parker Stadium began in earnest. This first drawing (top) called for an upper deck on the west sideline that would be ready for the 1966 season. The plan was later amended (middle) to adding 40 rows behind the existing stands for 1967. When it was finished (bottom), capacity was 40,593. On this particular afternoon, 41,494 wedged their way in to see Oregon State beat No. 1-ranked Southern California 3-0.

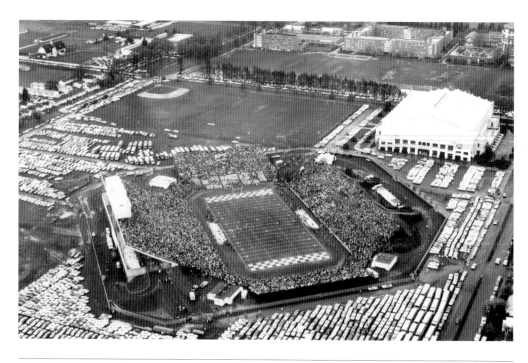

THE DAPPER GENTLEMAN visiting Dee Andros in his Gill Coliseum office is Beaver broadcaster Bob Blackburn, and there's a reason he's wearing a tuxedo as the 1967 season nears an end. Blackburn's tux was a part of the magical season of the Giant Killers, which came as Blackburn was wrapping up a long stint at OSU and becoming the voice of the new Seattle SuperSonics of the National Basketball Association.

With Oregon State playing at No. 2 Purdue University on October 21, Blackburn had to make a quick exit from the Sonics' first-ever home game, for which formal attire had been the order of the evening. Catching an overnight flight, Blackburn didn't have a chance to change before the Beavers' 22-14 upset win, and athletic director Jim Barratt decreed that Blackburn had to keep wearing the tux for broadcasts as long as the Beavers kept winning.

A 16-16 tie at No. 2 UCLA apparently wasn't enough to bring about a casual Saturday, and Blackburn was still in the formal wear when the Beavers recorded their historic 3-0 win over top-ranked and eventual national champion Southern California on November 11.

Blackburn and Andros are taking a look at the good-luck telegram signed by Oregon State fans in Portland and sent by KEX, the flagship station of the Beaver radio network. It took over an hour for the missive to clear the Western Union office in Corvallis.

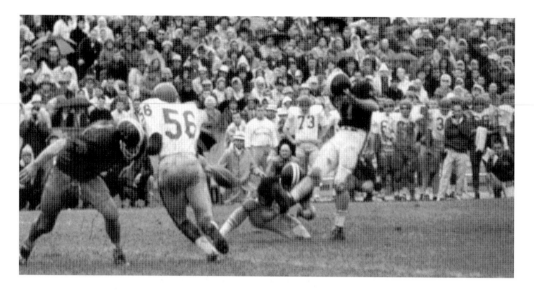

IT IS NOVEMBER 11, 1967, and Mike Haggard is booting a 30-yard field goal that gave Oregon State a 3-0 lead in the second quarter. OSU's defense made those points stand up for a win over the No. 1-ranked Trojans, cementing the No. 13-ranked Beavers' "Giant Killer" nickname for all time. Said OSU head coach Dee Andros, "It wasn't muddy, I can guarantee you. It was wet, but it was not muddy." OSU defensive tackle Jess Lewis recalled, "It was wet, and there were some bad spots in the field, but it wasn't sloppy-sloppy . . . it was slick, but there was some firm footing out there and everybody played on the same field . . . it was torn up some, but I don't know why they call it the 'Mud Bowl.'"

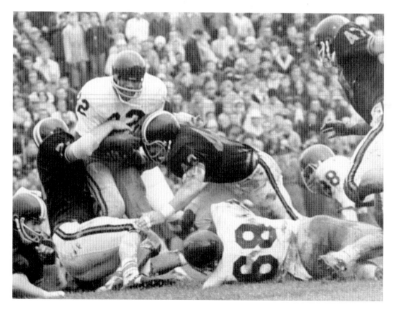

O. J. SIMPSON DIDN'T FIND the footing at Parker Stadium too slick on November 11, 1967, as the Southern California back scampered for 188 yards. Pictured here are OSU's Jon Sandstrom (No. 71), Skip Vanderbundt (No. 42), and Mike Groff (No. 47) popping Simpson hard enough to loosen his chinstrap.

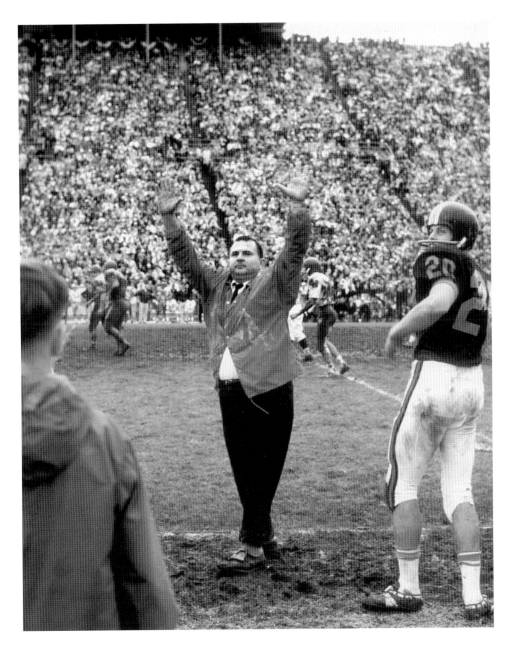

OREGON STATE HEAD COACH Dee Andros gestures to the fans behind the Beavers' bench at Parker Stadium late in the Beavers' 3-0 win over No. 1-ranked Southern California in 1967. Andros had told the press after the previous week's tie at No. 2-ranked UCLA and an earlier win at No. 2-ranked Purdue that he was tired of playing No. 2, and that it was time to bring on No. 1. "It wasn't very smart, but I mean, I said it," Andros said years later. "I told the kids when we were flying back, 'We're going to have a meeting as soon as we get back. Your old coach said some things and I want to explain them to you guys.' I just told them that I felt that way, and by God, I knew damn well enough that any team we wanted bad enough, we were going to win."

OREGON STATE HEAD COACH Dee Andros gets a ride across the field to shake hands with Southern California head coach John McKay after the No. 13-ranked Beavers' 3-0 win over No. 1-ranked USC in 1967. Recalled OSU defensive tackle Jess Lewis of the end of the game when it seemed all 41,494 in attendance were trying to crowd onto the field, "The explosion afterward . . . the excitement—of course, you were tired, too—tired from playing your hearts out. I remember the push of the people . . . people hanging on, pulling your jersey, trying to touch people. Everybody was just trying to be part of it."

OREGON STATE PLACEKICKER MIKE HAGGARD, from Parkrose High School in Portland, Oregon, relaxes and talks with reporters over the phone after his 30-yard field goal beat Southern California 3-0 in 1967. Said OSU head coach Dee Andros, "I never thought the three would stand up. But it did, and that's because our defense played a great game and then we kept the ball away from them."

1955–1975

THERE ARE ADVANTAGES to being named the head coach of *Playboy* magazine's preseason All-America team, but Dee Andros seems to be taking a hands-off approach to the perks. In 1968, Andros was named *Playboy*'s preseason Coach of the Year and flown to Chicago with the rest of the magazine's All-America team, which included OSU center John Didion and defensive tackle Jon Sandstrom.

JESS LEWIS RANKS as one of the greatest all-around athletes in Oregon State history, earning All-America honors as a defensive tackle in 1967 and NCAA wrestling championships at heavyweight in 1969 and 1970. The pride of Aumsville, Oregon, and Cascade High may be best remembered for running down O. J. Simpson from behind in the Beavers' 3-0 win over Southern California in 1967. Said Lewis 35 years later, "I never thought I'd get the mileage out of that play . . . but it was pretty exciting. Ol' Juice, he was a pretty good runner."

DEE ANDROS HAD A WELL-DESERVED image as a fun-loving guy, but at his core was a deep loyalty to his players, his friends, and most of all his wife, Luella, and daughter Jeanna (opposite). Here they get a smile out of seeing Dee carve into his namesake—the Great Pumpkin—one Halloween season. Andros's size and his penchant for orange clothing earned him the nickname early in his time at Oregon State.

During nearly four decades as head coach and an athletic administrator at Oregon State, Andros became best known for his motivational "talks," particularly those involving that school down US Highway 99W. It was Andros who first opined that the Civil War was played "for the right to live in the state." Steve Preece, who quarterbacked the Beavers from 1966 through 1968, once said of Andros, "Dee loved some individual Ducks . . . but in terms of 'The Ducks,' Dee hated the Ducks. Before the Duck games, we heard some of his greatest comments. That was when I found out that George Washington, Abraham Lincoln, and Jesus Christ all regretted not having played against the Ducks and getting to beat them."

Andros spent 11 seasons as OSU's head coach, going 51-64-1 from 1965 through 1975 and that included a 9-2 record against Oregon. Early on, his teams earned four runner-up finishes in the Pacific-8 Conference, but the conference policy prohibited any team other than its champion from going to a bowl game. This lack of national visibility in some of those postseasons was a contributing factor to OSU's slide in the 1970s.

The Beavers' mounting on-field misfortunes didn't negate Andros's popularity, though, and after resigning as head coach near the end of the 1975 season, he became Oregon State's athletic director. He served in that capacity until retiring at the end of 1986 but remained in the athletic department as a special assistant for the Beaver Club until he passed away in 2003. Appropriately his memorial service was held at OSU on Halloween.

Demosthenes Konstandies Andrecopoulos (Andros's full name) was born in Oklahoma City, Oklahoma, and served in the U.S. Marines during World War II, earning a Bronze Star for his combat service on Iwo Jima. How did a cook's assistant wind up toting a rifle into the fray? "Hell," Andros once snorted to an interviewer, "there wasn't any food."

He played at the University of Oklahoma after the war before joining the staff of legendary Sooner head coach Bud Wilkinson. He later served as an assistant coach at Kansas University, Texas Tech University, the University of Nebraska, the University of California at Berkeley, and the University of Illinois. His first head-coaching job was at the University of Idaho from 1962 through 1964, where he compiled an 11-16-1 record before moving on to OSU.

Parker Stadium Installs New Rug

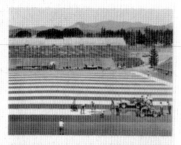

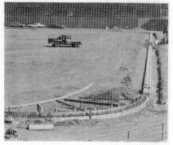

Installation of Oregon State's Astro Turf actually took less than a week, although the overall project of ground preparation and installation took up a major part of the summer. Early work (lower right) involved the removal of the grass turf, installation of drainage ditches around the field and filling and grading to achieve the proper slope for drainage. After this two layers of asphalt were installed (lower left). The cushioning padding was then put on and bonded to the asphalt (center, OSU defensive guard Bill Nelson was one of several students to help with the project). Crews from Monsanto then put into place (upper left) strips of the Astro Turf 15 feet wide from one side of the field to the other. The synthetic material was placed down in a striped appearance (upper right), with the gaps filled the second time around. Each strip of turf is bonded to the padding and to adjacent strips, in effect, forming one giant rug.

OREGON STATE FIRST put artificial turf in Parker Stadium in time for the 1969 season. A layout in that year's game program followed the installation and outlined the process for fans.

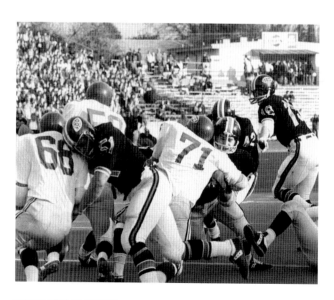

COLLEGE FOOTBALL CELEBRATED ITS CENTENNIAL in 1969, and most of the nation's teams sported a football-shaped decal with the numeral "100" on their helmets to honor the occasion. On November 15, the Beavers attained a 38-3 win over Washington State University in front of 23,679. OSU quarterback Steve Endicott hands off here to Dave Schilling, who is following the blocks of center Mike White (No. 51) and guard Scott Freeburn (No. 68).

UNDER THE DIRECTION of James Douglass, the 1970s Oregon State had one of the nation's most entertaining marching bands. Part of its attraction was its penchant for active, themed shows. A salute to Smokey the Bear might include the band forming a tree before emptying a dozen fire extinguishers to simulate a forest fire. A tribute to the United States Armed Forces could bring forth the shape of a marching soldier. The OSU band was regularly called upon to play at home games of the NFL's Oakland Raiders and San Francisco 49ers.

IT'S NOT EXACTLY THE COMMERCIAL where the kid hands Mean Joe Greene a Coca-Cola and gets Greene's jersey in return, but in this locker room scene after a 1971 game, it seems that a young admirer is handing OSU fullback Mike Davenport a beverage—and it's that other cola. From Estacada, Oregon, Davenport lettered from 1970 through 1972.

OREGON STATE FOOTBALL

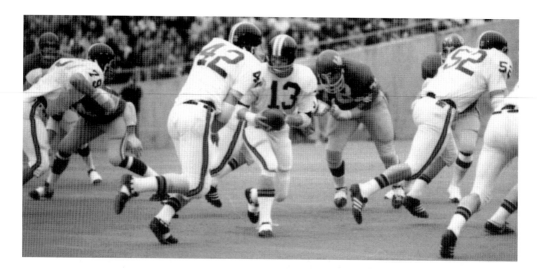

BEFORE THE 1971 CIVIL WAR, Oregon State fullback Dave Schilling had missed OSU's last five games with an injury, but he managed to play against Oregon in Eugene. He's taking the ball here from quarterback Steve Endicott.

Schilling, from Hillsboro, Oregon, rushed for 114 yards and three touchdowns in the Beavers' 30-29 victory. Afterward, Schilling told reporters, "I don't care about the stats. The only stat that counts is the score."

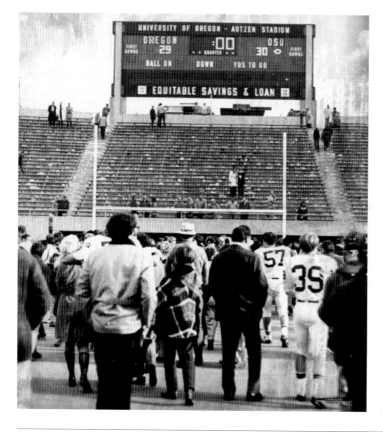

WHEN OREGON STATE visited Oregon in 1971, the final quarter saw four lead changes in the final 12 minutes in front of 43,000 people, and OSU won its eighth-straight Civil War, 30-29. As the teams trudged off the field, one Duck looked toward the heavens and said, "God must be a Beaver!" wrote Ken Wheeler of the *Oregon Journal*. In the locker room, head coach Dee Andros told his team, "You made a lot of people all over the country very, very proud of the Beavers."

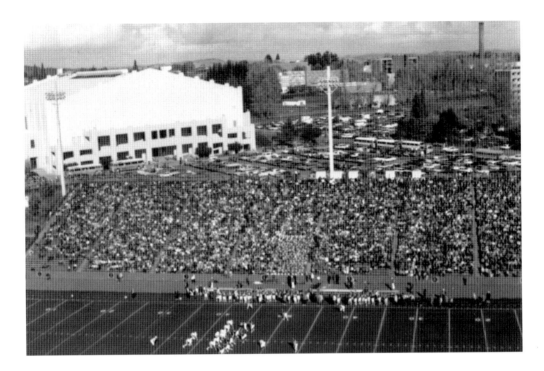

IT IS 1972 AND THE BEAVERS are losing to Washington 23-16 in front of 31,923 fans. This was the view from the upper rows of Parker Stadium's west grandstand until an upper deck was added to the east side in 2005.

THE COVERS OF OREGON STATE'S 1972 game programs featured Beavers at their summer jobs. For the homecoming game against Washington, the cover boys were wingback Wilson Morris (top) from Wilson High in Tacoma, Washington, feeding a veneer dryer at Georgia Pacific's plant near Corvallis and defensive guard Billy Joe Winchester (bottom) from Mount Miguel High in Spring Valley, California, climbing down from a truck at Corvallis Sand and Gravel.

OREGON STATE FOOTBALL

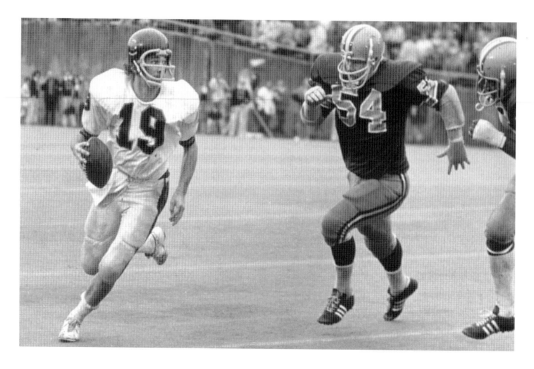

OREGON STATE QUARTERBACK STEVE GERVAIS is a little wide-eyed as he looks for either a passing target or running room in the 1973 Civil War in Eugene. The Beavers beat Oregon 17-14. From Puyallup, Washington, Gervais lettered from 1972 through 1975 and then became one of Washington's most successful high school coaches ever. Through 2005, his teams had won five state titles at three different levels.

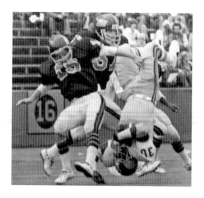

BY 1975, OREGON STATE had posted four straight losing seasons and some wanted a change at the top. Those who felt the Great Pumpkin could still get the job done printed up these stickers in support of Dee Andros, borrowing the slogan from a popular cigarette advertising campaign of the time.

Colorado State's Ron Harris (No. 30) takes a header after being spilled by Oregon State safety Jay Locey in the Beavers' 17-8 loss on October 11, 1975. Locey earned All-Coast honors as a senior in 1976. From Corvallis, Oregon, Locey eventually guided nearby Linfield to the NCAA Division III national title in 2004.

1955–1975

1 9 7 6 – 1 9 9 6

FOUR HEAD COACHES—Craig Fertig, Joe Avezzano, Dave Kragthorpe, and Jerry Pettibone—tried to revive Oregon State's football fortunes, with varying degrees of success. There were some all-passing attacks and some that were all running. They had home jerseys that went from black to orange and back to black again and helmets that went from black to orange to white. They had a coat of orange paint for parts of Parker Stadium, a roof to keep some fans dry while they watched the damp doings below, some seasons that reclaimed at least respectability, some upset wins that kept hope alive, and a lot of losses.

THE COACHES: Craig Fertig, 1976–1979; Joe Avezzano, 1980–1984; Dave Kragthorpe, 1985–1990; and Jerry Pettibone, 1991–1996.

THE ALL-AMERICANS: Steve Coury, split end, 1979 and Fletcher Keister, offensive guard, 1992.

THE GOLDEN YEARS: In 1978, 3-7-1 record; in 1988, 4-6-1 record; in 1989, 4-7-1 record; in 1993, 4-7 record; in 1994, 4-7 record.

THE WAIT-'TIL-NEXT-YEARS: Almost all of them. In 1979, 1-10 record; in 1980, 0-11 record; in 1981, 1-10 record; in 1982, 1-9-1 record; in 1987, 2-9 record; in 1990, 1-10 record; in 1991, 1-10 record; in 1992, 1-9-1 record; and in 1995, 1-10 record.

THE BEST OF TIMES: In 1977, beat No. 13 Brigham Young 24-19 in Corvallis; in 1978, beat No. 9 UCLA 15-13 in Corvallis; in 1981, beat Fresno State 31-28 in Corvallis after trailing 28-0 in third quarter; in 1985, beat Washington 21-20 in Seattle, Washington, after being 37-point underdogs; in 1988, beat Oregon 21-10 in Corvallis to end 13-year winless streak in Civil War; and in 1991, beat Oregon 14-3 in Eugene to end 15-game losing streak.

AROUND THE TIME JIMMY CARTER made a fashion statement about sweaters and United States presidents, Craig Fertig (opposite) was doing the same thing for head football coaches. This is his attire on the Parker Stadium sideline during a game in the late 1970s.

Fertig was Oregon State's head coach from 1976 through 1979, and even though his teams compiled an 8-36-1 record, they were usually good for one upset win per season in front of the home fans. The two most dramatic were in 1977, over No. 13-ranked Brigham Young 24-19, and in 1978, over No. 9-ranked UCLA 15-13. The Beavers also beat favored teams from California 10-9 in 1976 and Stanford 33-31 in 1979.

Fertig was also the man who switched OSU's jerseys from the black of the Tommy Prothro and Dee Andros years to something called "negligee orange." And there was the kickoff team, dubbed "the June Taylor Dancers" for the way they'd sashay from one side of the ball to the other in seemingly random patterns before the kick, hopefully confusing the receiving team's blockers as to their assignments.

Fertig came to Oregon State from the University of Southern California where he had been the offensive coordinator at his alma mater in 1975. He also was on John McKay's coaching staff with the Trojans from 1965 through 1973 before spending one year in the ill-fated World Football League as the offensive coordinator of the Portland Storm under Dick Coury. Fertig would later coach Coury's son, Steve, an All-America wide receiver at OSU.

Fertig played quarterback for McKay at Southern California. He was a member of the Trojan's 1962 national championship team and a captain of the 1964 club that lost out on a Rose Bowl berth to Oregon State. Fertig also appeared in several movies while at USC and arrived in Corvallis as a card-carrying member of the Screen Actors Guild.

STEVE COURY, AN ALL-AMERICA wide receiver from Lakeridge High School in Lake Oswego, Oregon, holds aloft a game ball after a Beaver win in the 1970s.

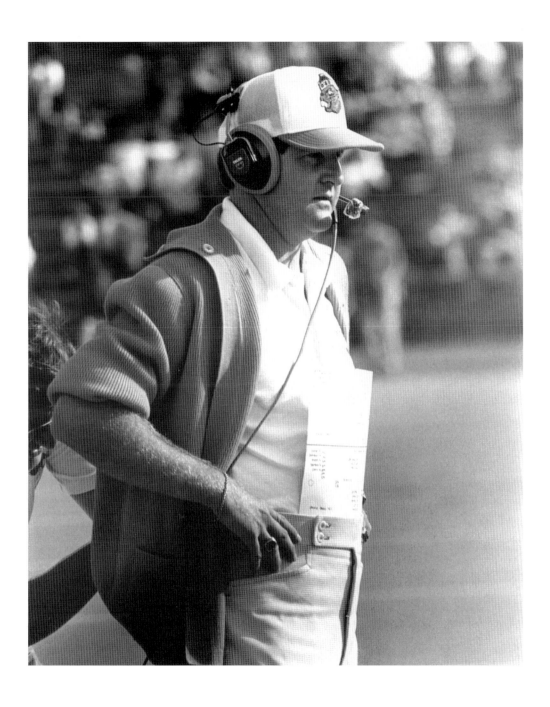

AT TIMES DURING the late 1970s, when Oregon State compiled a 9-46-1 record from 1975 through 1979, it seemed like this was the only way the Beavers were going to get a drive going at Parker Stadium.

THIS PHOTOGRAPH OF KERRY JUSTIN may be as good a reason as any for the near-extinction of football publicity shots that featured players flying around with no helmets on. A cornerback from Crenshaw High in Los Angeles, California, and East Los Angeles College, Justin lettered for the Beavers in 1976 and 1977. He then played with the National Football League's Seattle Seahawks and the United States Football League's New Jersey Generals from 1978 through 1988.

OFFICIAL PROGRAM $1.00

TENNESSEE
vs.
OREGON STATE

VOLS

NEYLAND STADIUM
SHIELDS-WATKINS FIELD
UNIVERSITY OF TENNESSEE
KNOXVILLE, TENNESSEE
OCTOBER 1, 1977

-MOODY-

When Oregon State visited the University of Tennessee in 1977, the dam didn't hold, as the Beavers were beaten 41-10 in Knoxville. A year later, though, the Beavers returned and held the Volunteers to a 13-13 tie as Tennessee had to come back from a 13-0 halftime deficit. OSU quarterback Steve Smith connected on scoring passes of 36 yards to Steve Coury and 44 yards to Dwayne Hall before Tennessee scored all its points in the fourth quarter. Both teams missed the point-after kick following their second touchdowns; for OSU, that ended a streak of 97 straight successful point-after kicks dating back to 1972.

OREGON STATE FOOTBALL

REPORTERS LEARNED TO ENJOY the postgame question-and-answer sessions with head coach Craig Fertig, who was at Oregon State from 1976 through 1979.

WHEN CRAIG FERTIG became Oregon State's head coach for the 1976 season, one of his moves was to change the color of the Beavers' home jerseys from black to orange. One result was the "Orange Crunch" theme, and orange hankies were handed out for Beaver fans to wave at home games.

"Fertig-isms"

In Craig Fertig, there is more than a slice of ham. There is a little Milton Berle, a little Steve Martin and a little Redd Foxx in the OSU grid mentor, who has been called "the Prince of Ad Lib in Oregon."

Here is a sampling of quips and witticisms from the master:

On BYU quarterback Gifford Nielsen's comment, "We do well because God is on our side," after the Beavers' defense had thwarted Nielsen and the Cougars, 24-19: "Somewhere, there must be a defensive God."

Of USC's 6-6, 280-pound offensive tackle Anthony Munoz: "Put windows in him, he'd look like an apartment building."

Of the Trojans' entire offensive front: "If they had to line up one more player with that group, they'd be out of bounds — that's how wide they are."

When asked what his instructions to the OSU kickoff team are: "Tackle the guy with the ball."

When asked why tailback James Fields didn't sing the national anthem at the Arizona State game in Tempe: "I asked (Coach) Frank Kush and he said no, it's not in their union."

On the Beaver defense's custom of holding hands in the huddle: "It's all right with me as long as they're not holding hands when they're trying to tackle somebody."

Of middle linebacker Kent Peyton checking his wrist band to help him call defensive signals: "He's not looking at his wrist watch to see if he can still make a date tonight."

On mirrors in the weight training room: "Some of our guys like to look pretty for their summer jobs."

On defensive tackle Greg Marshall: "He wants to be a coach. And I thought he was a smarter guy than that."

On quarterback John Norman — who missed nearly the entire 1976 season with a knee injury — after the Beavers' opening win against Syracuse: "I'm very happy to see him back alive and well."

On injuries suffered against Stanford: "We lost the trainer of our 1942 team (which was honored at the game) due to a concussion when he fell off the team bench."

On his young son, Marc, after the Beavers had defeated the Orangemen from Syracuse: "He asked me before the game if our quarterback would know the good guys in the orange helmets."

In picking the Washington State-Stanford game, with two of the nation's leading passers, Jack Thompson and Guy Benjamin, slated for action: "That one will begin Saturday afternoon and get over sometime Monday morning."

When asked what kind of a defense he would employ against WSU and Thompson: "We're going with a 6-3-3 ... that should really cover everything."

When asked about a successful halfback pass thrown by Karl Halberg in the Washington State game: "Well, Karl didn't complete one in practice all week so we figured it would work."

When he was late for a "Beaver Huddle" meeting in Portland: "I'm late because the TV people were a little long-winded. They wanted to hear my game plan, and we don't have it. Heck, it's only Thursday."

After the Beavers' loss to Stanford: "Look at the bright side of it. SC's lost three out of four. I'm an alum there and I'm upset about that. You should see the letter I've written."

On criticism of a Beaver quarterback: "It's easy to criticize quarterbacks, but our guards didn't play very well, either. Most people don't know what a guard is supposed to do. In fact, most of our guards don't know what the heck they're doing."

Recalling a great college performance he had against Oklahoma: "I thought I was the slickest thing since rubber tires."

When asked how his quarterback could get tackled for a safety in a game: "Well, we tell our quarterbacks not to get tackled anywhere."

On Arizona State wide receivers

John Jefferson and Ron Washington: "Washington and Jefferson. Isn't that the name of some school?"

On his boys' football camp: "My boy was the youngest in camp and he even picked up a new vocabulary. It was the first time he'd ever been away from Mom and he didn't even try to crawl home once."

On injuries at the boys' camp: "We had only one, and that was a pulled back muscle when a 10-year-old was reaching across the training table for a second helping of pie."

On durable defensive tackle Greg Marshall: "He got hurt again, but that's nothing new. I don't think there is anything left on Greg to injure."

When freshman running back Willie Johnson was comforted by fellow rookie, 16-year-old Reggie Williams, in his first game: "Old Reggie, the old veteran, went over to calm Willie down."

On criticism that he should have revealed to the press that tailback James Fields was not going to be in action for the Washington game: "During World War II we didn't let 'Coach' Hitler know just where and when George Patton would pop up, did we?"

On the need for a booming punter: "I've told our staff that our first scholarship next year will be given to a punter and the second to the guy who brings him in."

On the difference between the Craig Fertig of 1976 and the Fertig of 1977: "About 10 pounds."

On his offensive backfield: "We had a Japanese kid at quarterback, a Samoan at fullback, a black at running back and a white guy at flanker. It's an equal opportunity backfield."

After sportscaster Jimmy Jones — who handles the "Craig Fertig" TV show — committed a faux pas after the Cal game. "And the Bears came away with a 41-17 injury . . . I mean victory": "It was an injury to us, too, Jimmy."

WHEN OSU PUT TOGETHER its football-recruiting brochure for 1977–1978, Fertig's comedic stylings got a page of its own. He picked up a thing or two as a player and assistant coach for John McKay at Southern California, as McKay was noted for his low-key sense of humor.

MIRAGE BOWL

MIRAGE BOWL 1980

NOVEMBER 30th, SUNDAY
TOKYO OLYMPIC MEMORIAL STADIUM

UCLA vs OREGON

OREGON STATE WENT to great lengths to play UCLA in 1980, but the Beavers didn't get much credit for it as OSU was billed as "Oregon" on the cover of the Mirage Bowl program. The Tokyo tussle wound up in UCLA's favor by a 34-3 score before a crowd of 86,000, ending the Beavers' season with an 0-11 record—OSU's first winless season since an 0-2-1 campaign in 1895.

In 1981, OREGON STATE was billing the football team as "the Orange Forces." Coming off an 0-11 season, the Beavers needed a boost, and the marketing campaign provided it in the form of a 45 r.p.m. record. The lyrics to the rock ditty went as follows:

The Orange Forces are givin' everybody
the power
The Orange Forces are changing the world
in a couple of hours—
The ground starts to shake, the crowd
starts to roar
Every time those Beavers score.
Be a believer, believe in the Beavers;
Be a part of the Orange Forces.
Okay choir, can you spell?
O! You've got to see them play
R! You ready for football
A! Great time on each great Saturday
N! That's not all—
G! You're never goin' to forget it.
E! These are the good times, you know
the score.
Be a believer, believe in the Beavers;
Be a part of the Orange Forces.
The Orange Forces, they're takin' the
field again.
The Orange Forces, fightin' it out with
the Pac-10.
Sometimes they pass, sometimes
they run
Whatever they do is exciting and fun!
Be a believer, believe in the Beavers
Be a part of the Orange Forces.
You're gonna shout! You're gonna cheer!
You're gonna believe the power is here!
Be a believer, believe in the Beavers!
Be a part of the Orange Forces!

Despite the record, the beating went on. The Orange Forces wound up 1-10, coming from 28 points down in the third quarter to beat Fresno State 31-28 in the season-opener before dropping their last 10 games.

A PERSON CAN WORK UP quite an appetite coaching, even in the preseason. During fall camp of 1983, Oregon State held a salmon bake to give fans a chance to meet the Beavers, and head coach Joe Avezzano found a few moments to sign a photograph for a young fan (opposite) and then dig into the corn-on-the-cob (above). Avezzano was at OSU from 1980 through 1984, compiling a 6-47-2 record that included just two Pacific-10 wins. His tenure may well have been the low point in OSU's string of 28 straight losing seasons.

The Avezzano years weren't without a memorable moment or two, though. After OSU went 0-11 in 1981, the Beavers began the 1981 campaign with a 31-28 home win over Fresno State University. To do it, Oregon State had to rally from a 28-point deficit in the third quarter, which at the time was the biggest comeback in NCAA Division I-A history. The next week, the Beavers lost 27-24 at Louisiana State University,

starting a string of 15 straight losses that lasted well into the next season.

Then there was that 0-0 game in the 1983 Civil War, the last scoreless tie in NCAA Division I-A history, proving that not all the memorable moments were highlights.

Avezzano came to OSU after spending three seasons as offensive coordinator at Tennessee, and he'd also been the offensive line coach at University of Pittsburgh from 1973 through 1976, helping the Panthers win the national title in his final season. After being dismissed following the 1984 season, Avezzano was offensive line coach at Texas A & M University from 1985 through 1988 before embarking on a long career in the National Football League with the Dallas Cowboys and Oakland Raiders. Avezzano was part of Dallas' Super Bowl champions in the 1992, 1993, and 1995 seasons and was the NFL Special Teams Coach of the Year in 1991, 1993, and 1998.

JUST OVER HALFWAY THROUGH the 1983 season, it had been four years to the week since the Beavers had won a Pacific-10 game, Oregon State's students were ready to celebrate when the Beavers beat Stanford University 31-18 on October 29 to end a 30-game conference winless streak. "Coach (Joe) Avezzano jumped up on the table and we sang our winning fight song, which we've sung so few times," linebacker James Murphy said of the locker room scene. "We're just lucky we still remember the words."

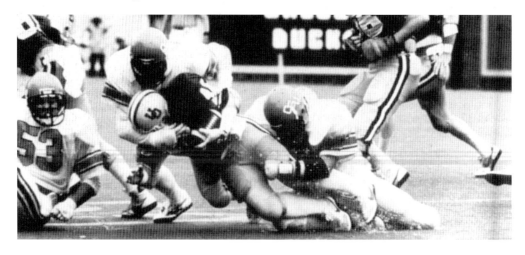

AS CAN BE SEEN from the water being kicked up as a pair of Oregon State defenders bring down this Duck, the 1983 Civil War in Eugene was soggy. And as soggy things can be, it was a mess. OSU and Oregon wrapped it up tied 0-0 after 11 fumbles (six of them lost), five intercepted passes, and four missed field goals (two by each team). George Pasero of the *Oregonian* wrote, "(Oregon head coach Rich) Brooks said there should be a way to break a tie in the college game. Maybe not; the Beavers and Ducks might still be playing next week."

RICH GONZALES PLAYED just one season at Oregon State, taking over the quarterback spot for the injured Erik Wilhelm early in 1985. The freshman from Diamond Bar, California, left Beaver fans with one of the school's all-time great victories, though, guiding the Beavers to a 21-20 win at the University of Washington on October 19. He was 26-for-46, passing for 298 yards and a touchdown that afternoon as the Beavers upset a Husky squad that was a 37-point favorite going into the game.

IT IS RIGHT THERE in lights—Oregon State has beaten Washington at Husky Stadium in 1985, and Beaver fans are celebrating. OSU, which had lost to Southern California 63-0 and Washington State 34-0 the previous two weeks, arrived in Seattle to mocking from the local media. One columnist wrote that the Beavers "are not only an embarrassment to themselves and their fans . . . they are an embarrassment to the Pac-10 Conference." The Beavers saw that and more, and they later told just how much it stung and how much it had motivated them. *Seattle Times* columnist Blaine Newnham wrote, "There is no question that Seattle's media underestimated (OSU head coach Dave) Kragthorpe and the determination of the young men playing for their pride . . . The Huskies have dodged bullets since beating UCLA and they honestly deserved to lose this game. They could have lost to Oregon and Cal. If they had to lose, however, they picked the right spot. It was a day when pride was more important than bowl games, when money and tradition didn't matter. We should all learn from it."

THERE WAS GOOD REASON that new head coach Dave Kragthorpe and record-setting wide receiver Reggie Bynum found themselves with a flying object on the cover of the 1985 media guide (opposite), because footballs would be flying that fall. Kragthorpe would coach at OSU from 1985 through 1990, posting a 17-48-2 record with some notable successes along the way.

Kragthorpe's first team won its first two games, but eventually went to Washington as a 37-point underdog. The Beavers knocked off the Huskies 21-20 when Lavance Northington recovered a punt blocked by Andre Todd in the end zone. In 1986, OSU went back to their head coach's old haunt and upset Brigham Young University 10-7.

In 1988 and 1989, Oregon State flirted with winning seasons, posting back-to-back, four-win seasons by going 4-6-1 and 4-7-1; the Beavers hadn't won more than three games since 1971. OSU capped the 1988 season by beating Oregon 21-10 for the Beavers' first Civil War win since 1974.

Kragthorpe took the OSU job after spending a couple of years as athletic director at his alma mater, Utah State University, when he got the itch to go back into coaching. He'd been the offensive coordinator and offensive line coach at Brigham Young from 1970 through 1979, helping develop the Cougars' ball-control passing offense. From BYU, he'd become head coach at Idaho State University, which had lost 18 straight games when Kragthorpe arrived; two years later, the Bengals were NCAA Division I-AA national champions.

Bynum had a terrific career at Oregon State, earning All-Pacific-10 honors in 1984 and 1985 and All-Coast honors as a senior. Coming out of Independence High School in San Jose, California, Bynum left OSU as its career leader in pass receptions and receiving yardage before going on to play for the Buffalo Bills of the National Football League (NFL).

ROBB THOMAS, No. 18, was a wide receiver from Corvallis, Oregon, who provided a deep threat for Oregon State from 1985 through 1988. He went on to play from 1989 through 1998 for the Kansas City Chiefs, Seattle Seahawks, and Tampa Bay Buccaneers in the NFL.

OSU'S AIR EXPRESS '85

OREGON STATE QUARTERBACKS ERIK WILHELM (back left with the football) and Dave McLaughlin (back right with the football) are getting plenty of protection in this 1986 publicity photo dubbed "The Bodyguards," featuring OSU's offensive linemen. McLaughlin's only season at Oregon State was 1986, as he transferred from Tulane University after the 1984 season and redshirted in 1985; he was originally from Agoura, California. From Lakeridge High in Lake Oswego, Oregon, Wilhelm lettered from 1985 through 1988 and left OSU as the school record holder in passing yards, touchdown passes, and total offense. He played in the NFL for the Cincinnati Bengals and Arizona Cardinals from 1989 through 1997.

AT TIMES IN THE 1980S, it seemed that the autumnal philosophy at Oregon State was "another win, another goalpost." This time, it was an 18-17 win over UCLA on October 22, 1989, that turned the OSU student body into Destruction Engineering majors. The Beavers had secured the victory when a 55-yard Bruin field goal try fell short in the final minute. "I was scared—it looked like it had enough to get there. We were holding hands on the sideline and we said a little prayer," OSU fullback Pat Chaffey told reporters.

1976–1996

THE UNIVERSITY OF WISCONSIN has its Cheesehead headgear, and Oregon State had its answer in the late 1980s, though a tad more subtle. An OSU marching band member at the 1989 Civil War in Eugene sports her Beaver nose and teeth.

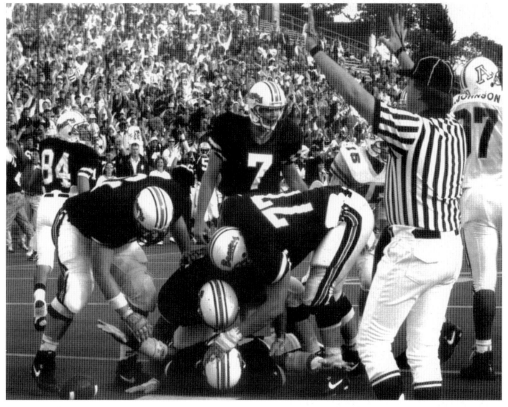

OREGON STATE FULLBACK JAMES JONES is at the bottom of this pile, celebrating a touchdown in the Beavers' 35-21 win over No. 21-ranked Arizona on October 13, 1990. Said OSU running back Reggie Pitchford, "We weren't concerned about them being ranked. We were determined to play all four quarters and that's what happened. We proved to ourselves that the talent is there."

Esera Tuaolo

IT'S AN OREGON STATE UNIFORM Esera Tuaolo is wearing on this card. Tuaolo was All-Pacific-10 as a defensive lineman in his final two OSU seasons in 1989 and 1990, and he also performed vocally, including singing the national anthem prior to basketball games. He played nine seasons in the NFL for the Green Bay Packers, Minnesota Vikings, Jacksonville Jaguars, Atlanta Falcons, and the Carolina Panthers. A few years after retiring, Tuaolo went public with his homosexuality. Telling his story in *ESPN Magazine* in 2002, Tuaolo outlined the life that he, his partner, and their adopted 23-month-old twins were living, summing it up "Got a house in the suburbs and a lawn and two dogs. I've recorded two pop albums . . . I'm just your typical gay Samoan ex-nose tackle who'd like to break into show biz."

ONE OF JERRY PETTIBONE'S GOALS when he became Oregon State's head coach in 1991 was to re-instill a sense of tradition in the football program. A product of that effort was the Bronze Beaver, which was installed at the base of the ramp into Parker Stadium in 1992. When OSU took the field just before kickoff, each player and coach was to touch the Bronze Beaver as he passed by the statue. The sculpture was a combined effort of the OSU student body and the football program. The plaque on the Bronze Beaver's base read, "As a symbol of our quest for excellence in the classroom and on the field of competition, this statue is a representation of the unity between the student body and the student athletes of OREGON STATE UNIVERSITY. September 5, 1992. Go Beavers." Pettibone also encouraged the practice of posting an around-the-clock contingent of OSU students to guard the Bronze Beaver from vandalism by Oregon students during the week leading up to the Civil War.

THIS IMAGE WAS CREATED to celebrate the 100th anniversary of Oregon State football in 1993. Pictured here is halfback Don Durdan from Eureka, California, who lettered from 1939 through 1941, morphing into quarterback Terry Baker, who lettered from 1960 through 1962, and then into halfback J. J. Young from South Pasadena, California, who lettered from 1991 through 1994.

THE WILLAMETTE & PACIFIC RAILROAD decorated one of its freight cars in honor of Oregon State, and the piece of rolling stock could occasionally be seen from the upper rows of Parker Stadium as it passed by on the tracks along NW Washington Way.

THE COVER OF OREGON STATE'S 1991 media guide (opposite) gave a glimpse of the building blocks for the "spread option" offense that new head coach Jerry Pettibone was bringing to OSU. The idea was to spread the field, run the option effectively enough to draw a defense toward the line of scrimmage, and then use play-action passes for big gains.

OSU indeed became one of the nation's top rushing teams during Pettibone's tenure, but generally struggled in—when it didn't entirely disdain—the passing game. Still the spread option was an unusual enough look for opponents to defend that the Beavers managed four-win seasons in 1993 and 1994, matching their best records since 1971.

Pettibone's first season saw OSU trying to shift pass-oriented personnel from the Dave Kragthorpe era into a run-oriented offense, and that led to losses in the Beavers' first 10 games. Things finally clicked in the Civil War, with the Beavers taking a 14-3 win at Oregon. For several weeks prior, OSU had spent part of each practice focusing on the Ducks. The day before the game, the Beavers practiced at Autzen Stadium and closed the session by rehearsing carrying their seniors off the field after a win.

By 1995 and 1996, OSU slipped to records of 1-10 and 2-9, and Pettibone retired from coaching. He finished with a six-season record of 13-52-1. Pettibone came to Oregon State from Northern Illinois University, where his six seasons included a 9-2 record in 1989 and the nation's top rushing offense in 1990 at 344.6 yards per game. Behind Pettibone in the photo is the original Valley Football Center, which opened in 1991. The three-story building was completely rebuilt six years later, roughly tripling in size.

TIM ALEXANDER COULD COUNT 100-yard games in rushing, passing, and receiving during his Oregon State career from 1995 through 1998. The triple threat from Riverview High School in Sarasota, Florida, played both quarterback and wide receiver for the Beavers.

1991 OSU FOOTBALL

"Bone"

"I"

"Double Slot"

Jerry Pettibone
Head Coach

OREGON STATE HEAD COACH Mike Riley (center) and Southern California head coach John Robinson (right), share a smile before their teams met on November 15, 1997, at Parker Stadium where the Trojans won 23-0. Riley had spent the previous four seasons as Robinson's assistant head coach, offensive coordinator, and quarterbacks coach at USC.

5

1997–2005

HAVING LOOKED FAR AND WIDE for a head coach that would end Oregon State's string of losing seasons, the Beavers finally turned to a hometown boy when Mike Riley was hired for the 1997 season. Riley nearly ended the frustration in his first two seasons, but OSU fell just a few points short in several late-season games. The biting disappointment of Riley's departure to become a head coach in the National Football League was assuaged when Dennis Erickson, who had won two national championships at the University of Miami, was named his successor. Winning seasons, bowl games, a conference co-championship, and a general era of competitiveness, success, and good feeling was ushered in, and Riley continued it upon his return in 2003.

THE COACHES: Mike Riley, 1997–1998, 2003–2005; Dennis Erickson, 1998–2002.

THE ALL-AMERICANS: Inoke Brecketerfield, defensive end, 1998; Ken Simonton, running back, 2000; DeLawrence Grant, defensive end, 2000; Chris Gibson, center, 2000; Dennis Weathersby, cornerback, 2001–2002; Steven Jackson, running back, 2002–2003; Mitch Meeuwsen, free safety, 2004; Mike Hass, wide receiver, 2004–2005.

THE GOLDEN YEARS: Almost all of them. In 1999, 7-5 record, O'ahu Bowl loss; in 2000, 11-1 record, conference cochampions, Fiesta Bowl win, ranked as high as No. 5; in 2002, 8-5 record, Insight Bowl loss, ranked as high as No. 23; in 2003, 8-5 record, Las Vegas Bowl win, ranked as high as No. 22; in 2004, 7-5 record, Insight Bowl win.

THE WAIT-'TIL-NEXT-YEARS: In 1997, 3-8 record.

THE BEST OF TIMES: In 1998, beat No. 15 Oregon 44-41 in Corvallis in double-overtime; in 2000, beat No. 8 Southern California 31-21 in Corvallis to end losing streak against USC dating back to 1967, beat No. 5 Oregon 23-13 in Corvallis for share of conference title, beat No. 10 Notre Dame 41-9 in Fiesta Bowl in Tempe, Arizona; in 2001, beat No. 8 Washington 49-24 in Corvallis; in 2004, beat Notre Dame 38-21 in Insight Bowl in Phoenix, Arizona.

MIKE RILEY PROWLS the Oregon State sideline (opposite) during his first stint as head coach (1997 and 1998), which ended with an 8-14 record and newfound hope for the Beavers. The final game of that stretch was a double-overtime, 44-41 win over Oregon at Parker Stadium, giving OSU its first five-win season since 1971.

Taking the job at Oregon State was a homecoming for Riley, who had grown up in Corvallis as his father Bud was an assistant coach on Dee Andros's staff in the 1960s and early 1970s. Riley quarterbacked Corvallis High School to a state championship in 1970.

"This is obviously a humbling experience," Riley said when he was introduced as head coach on December 13, 1996. "I see so many people out there, it's exciting, friends and people who have shaped my life. I just know that I'm going to bring everything I can to the program to see what we can do. We have no magic formula or crystal ball to work with."

Riley had been part of championships at nearly every level prior to becoming the Beavers' head coach. In addition to the state title at Corvallis and a helping win an NAIA Division II national title at nearby Linfield College as an assistant coach, he had played for Alabama's national champs in 1973, been a graduate assistant at the University of California when the Bears won a Pacific-8 co-championship in 1975, been an assistant coach and head coach for the Winnipeg Blue Bombers when they won the Canadian Football League's Grey Cup on three occasions, and helped the University of Southern California to two Pac-10 championships as an assistant coach.

"Mike is a special person to every player and coach here," USC head coach John Robinson said upon Riley's hiring at OSU. "Some guys come into your life and really have a positive influence. Others just come and go. Everyone who has ever known Mike thinks he's the world's greatest guy."

Wrote Dwight Jaynes in the *Oregonian*, "I don't think the Beavers have had the opportunity to hire anyone for this job with these kinds of credentials. Usually, someone with this much going for him wouldn't be interested in OSU. But Riley has a love for the state and the university where his father worked, and it has been with him for life. More than anyone else who has applied, he knows the difficulty of this task. Yet he not only wants the job, he is convinced he can win."

After the 1998 season, Riley was offered the chance to be head coach of the San Diego Chargers of the National Football League, and he took the position. His story at Oregon State would continue, though, when he returned as head coach for the 2003 season.

OREGON STATE FOOTBALL

It was a dark and stormy night, but at this moment, practically no one at Parker Stadium cared. Ken Simonton has just crossed the goal line to give Oregon State a 44-41, double-overtime Civil War victory on November 21, 1998. It was Simonton's fourth touchdown of the game, capping a wild evening where he rushed for 157 yards.

OSU tied the game on a 30-yard pass from Jonathan Smith to Tim Alexander with 1:27 to play, and then looked as though they had won when a Duck pass apparently fell incomplete on fourth down in the first overtime. Fans surging onto the field obscured the flag thrown for a pass interference penalty. After a delay to clear the field, Oregon tied the game at 38-38. The Ducks grabbed a 41-38 lead in the second overtime before Simonton scooted 16 yards off a block from tight end-turned-blocking back Martin Maurer.

"Kenny saw the hole and shot through it right off my tail. He went right down the sideline and I knew he was in," Maurer told reporters. Added Simonton, who reached the 1,000-yard mark in his freshman season, "I'll be dancing tonight."

FOR THE 1999 SEASON, Oregon State's home stadium got a new name. After being called Parker Stadium for its first 46 seasons, the stadium was renamed Reser Stadium in honor of OSU alums Al and Pat Reser, who made a seven-figure donation to OSU athletics—the largest gift ever to the Beavers.

OREGON STATE WIDE RECEIVER Roddy Tompkins celebrates a touchdown catch in the Beavers' 55-7 win over UCLA on October 23, 1999, at Reser Stadium. The blowout victory over one of the Pacific-10's traditional powers was an indication that Oregon State had truly rejoined the conference in football. Said UCLA flanker Freddie Mitchell, "It was embarrassing. I almost don't want to go back to L.A." An outstanding high school sprinter from Victoria, Texas, Tompkins was recruited by Jerry Pettibone and played from 1996 through 1999.

AT LAST, BEAVER NATION'S long national nightmare was over. It is November 6, 1999, and Tevita Moala is in the process of ending 28 years of football frustration by scoring the touchdown that ended a string of losing seasons dating back to 1971. Moala, a linebacker from Hawthorne, California, returned a fumble 24 yards deep in the fourth quarter to wrap up a 17-7 win over the University of California, OSU's sixth victory of the year. The Beavers rallied for 15 points in the fourth quarter for the win, sparking an on-field celebration by many of the 35,520 fans. "I got trapped on the field," OSU defensive tackle Shawn Ball said. "I saw grown men, 45 years old, just bawling, crying their eyes out." Said Oregon State head coach Dennis Erickson, "When I talked to our players (after the game), I said this isn't just for the team in here. It's for everybody that's played at Oregon State. It's for every fan that's been here through the last 30 years. This is six wins for all of them."

 Jeep Oahu Bowl II
University of Hawaii vs Oregon State
Aloha Stadium - Christmas Day 1999

FOR A COUPLE OF DECADES or so, Oregon State fans could be forgiven for frequently wondering if they'd ever see this again—an OSU bowl team. The 1999 squad ended a 35-year drought, reaching the Oʻahu Bowl against Hawaiʻi. They had their team picture commemorating the trip taken at a luau (above). The Beavers lost 23-17 to the Rainbow Warriors on their home field at Aloha Stadium, but in this instance perhaps just getting there was enough. Thousands of OSU fans made the trip for the Christmas-day game, picked up a copy of the program (right), and saw Ken Simonton rush for 157 yards and two touchdowns, including one that got the Beavers within a touchdown with just over a minute to go. OSU recovered the onside kick but had the recovery voided by a penalty, and Hawaiʻi managed to run out the clock.

Oregon State's surge toward a share of the 2000 Pacific-10 championship began on September 30, when the Beavers beat Southern California for the first time since 1967. In OSU's 31-21 win over the No. 8-ranked Trojans, Ken Simonton carried the ball 37 times for 234 yards and three touchdowns, including the game-clincher on a 36-yard run with 1:36 to play. "He's the guts of this football team," OSU running backs coach Dan Cozzetto said. "The things he does are unbelievable for his size. He doesn't have all-out burning speed, but you couldn't tell him that on the final play against USC."

HOW DOES ONE END a 32-season losing streak against Southern California? Possum power. In the second quarter of Oregon State's 31-21 win over the No. 8-ranked Trojans on September 30, 2000, a marvelous marsupial found its way onto the Reser Stadium turf at the back edge of the south end zone. It went the length of the field, receiving a roaring ovation as it crossed the north goal line. As the OSU *Daily Barometer* noted, the possum's 100 yards topped USC's 63 yards rushing.

DESPITE WHAT THIS FOOTBALL CARD from 2000 may say, James Allen was anything but a weak linebacker. In fact, the weakside linebacker from Jefferson High School in Portland, Oregon, turned in one of the finest series by a defensive player in OSU history on November 11, 2000, at the University of Arizona. With the game tied 3-3 midway through the first quarter, he first recorded a tackle behind the line of scrimmage before sacking the quarterback on the next play and then coming from nowhere on third down to stop a run well short of first down yardage. Arizona punted, OSU scored, and the Beavers were on their way to a 33-9 win. "My three-and-out," Allen recalled with a smile during his senior season. He went on to play for the New Orleans Saints in the National Football League.

WHY IS THIS MAN SMILING? Because he's just a few moments away from accomplishing what many said couldn't be done.

It is November 18, 2000, and Oregon State is putting the finishing touches on a 23-13 win over Oregon. Dennis Erickson, in just his second season as head coach at OSU, has a team that is about to earn a share of the Pacific-10 championship and put the Beavers in a Bowl Championship Series game only two years after the Beavers had endured their 28th consecutive losing season. "When you go 10-1 at a school that has never been 10-1 and was at rock-bottom a few years ago, it doesn't get any better than that," Erickson told reporters after the game.

The Beavers would go on to beat Notre Dame 41-9 in the Fiesta Bowl and finish ranked in the top-five nationally. In his stay at OSU from 1999 through 2002, Erickson's teams went 31-17, made three bowl trips, and had that share of a Pac-10 title.

All that made for just one more glittering item on Erickson's resume, which already included two national championships while coaching at the University of Miami from 1989 through 1994. As a head coach, he'd also been a big winner at the University of Idaho, finished at .500 in one season at the University of Wyoming, and turned around Washington State University in two seasons there.

After his successful run at Miami came an ill-fated stint as head coach of the National Football League's Seattle Seahawks, where his teams were 31-33, and he was relieved after four seasons. His firing coincided with OSU head coach Mike Riley's departure to become head coach of the NFL's San Diego Chargers, and Erickson contacted OSU about taking over as head coach.

"I've always felt that campus and town is as good as there is," was how Erickson described the OSU situation to reporters prior to the Fiesta Bowl. "If there was a commitment, that you could win. Obviously, Mike (Riley) showed you could be competitive."

OSU cornerback Keith Heyward Johnson said that week, "He (Erickson) was a little more assertive that this will happen. He said we'd get to the Rose Bowl. . . . Well, we did win the Pac-10 championship. Coach Erickson instills confidence that we know we'll win every game."

While at OSU, Erickson spurned several other college coaching opportunities. After four seasons, though, the San Francisco 49ers came calling, and Erickson left Corvallis to take another shot at building a winner in the NFL.

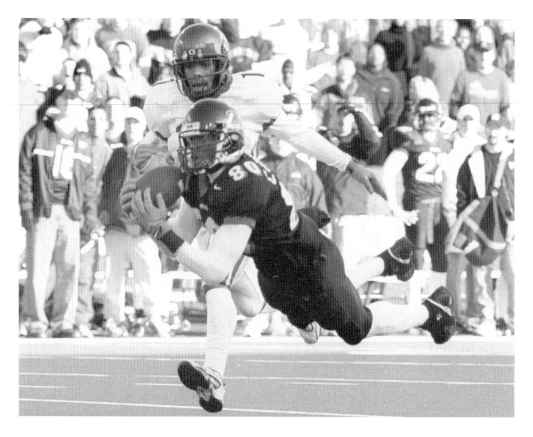

CHAD JOHNSON MADE THE COVER of *Sports Illustrated* for this catch in Oregon State's historic 23-13 win over Oregon on November 18, 2000, at Reser Stadium. The diving grab was Johnson's only catch of the day, but it was good for 44 yards and a load of momentum as the No. 8-ranked Beavers built an early 17-0 lead against the No. 5-ranked Ducks.

IT WAS APPROPRIATE that Oregon State tight end Martin Maurer was one of the Beaver seniors featured on the cover of the program for the 2000 Civil War. Maurer's father, Andy, played for Oregon before going on to a career in the NFL and his uncle Dick Maurer had played for OSU. After the Beavers' 23-13 win, Martin told Austin Murphy of *Sports Illustrated* magazine, "To knock the Ducks out of the Rose Bowl—it feels awesome. I'd love to be in Oregon's locker room right now."

1997–2005

THERE WAS PLENTY OF REASON to celebrate in Oregon State's locker room after the 2000 Civil War. In the biggest football game in the state's history, the No. 8-ranked Beavers had wrapped up a share of the Pacific-10 championship by beating No. 5-ranked Oregon 23-13 in front of 36,044 fans and a national television audience. The white caps and at least one T-shirt proclaiming the title are already on a number of the Beavers as Ken Simonton leads the celebration along with tailback Patrick McCall (far left, white shirt), defensive back Aaron Wright (No. 8), linebacker Tevita Moala (white shirt, white cap), wide receiver James Newson (No. 2), and wide receiver T. J. Houshmandzadeh (No. 18).

The win capped a wild week in Corvallis as excitement started building as soon as OSU and Oregon had won the previous weekend. The Beavers and Ducks were meeting for the first time with both teams ranked in the top 10 and both still had a chance at the Pac-10's berth in the Rose Bowl. OSU's postseason guide said of the game, "Much of the country had been looking forward to this game for nearly a month. Much of the state had been looking forward to it for more than a generation." The proceedings at Reser Stadium were even graced by legendary ABC broadcaster Keith Jackson, working his first-ever game at Oregon State.

Oregon State took advantage of six Oregon turnovers, including three interceptions by Beaver free safety Jake Cookus. OSU took control of the game early, going up 14-0 on touchdown passes of 31 and 49 yards from Jonathan Smith to Robert Prescott in the first quarter. The closest Oregon could get after that was 23-13 on a touchdown early in the fourth quarter, but the Beavers stopped the two-point conversion, and the Ducks wouldn't score again.

WHEN THE ANNOUNCEMENT came during a television broadcast that OSU would meet the University of Notre Dame in the 2001 Fiesta Bowl, it set off a celebration among the Beavers in the Valley Football Center. In two years, Oregon State had gone from 28 straight losing seasons to a Pacific-10 co-championship and one of the nation's top postseason games. As OSU quarterback Jonathan Smith said of that year's team, "We were sitting around figuring out how this team came together and we realized that we are a collection of southern California rejects and Oregon white trash."

WHEN THEY PAINTED THE FIELD at Sun Devil Stadium for the 2001 Fiesta Bowl, the school names in the end zones offered a graphic contrast in a matchup of one of the biggest "haves" against one of the traditional "have nots" in college football. Notre Dame had won 11 national titles and was perhaps the biggest name on the college scene, while OSU was playing in just its sixth bowl game but had become one of the great Cinderella stories in sports by going from 28 straight losing seasons to a top-five ranking in just two years.

OREGON STATE QUARTERBACK Jonathan Smith takes a question at a media session a few days before the 2001 Fiesta Bowl. From Glendora, California, Smith walked on at OSU but left as the school's all-time leader in passing yards, touchdown passes, and total offense. Not bad for a guy who was mistaken for a team manager by head coach Dennis Erickson the first time they met. "He's 5-foot-10. That's a deficiency to some people," Erickson said. "But he's smart, he understands what's going on, he knows where to go with the ball, he knows exactly what we want."

OREGON STATE WIDE RECEIVER Chad Johnson signs autographs for youngsters at the Fiesta Bowl Youth Football Clinic on December 31, 2000. From Miami Beach, Florida, by way of Santa Monica College, Johnson played just one season for the Beavers before making a bigger name for himself with the NFL's Cincinnati Bengals. He is not only known for his pass-snagging talents, but also for his touchdown celebrations such as mimicking a marriage proposal to a cheerleader, doing the "Riverdance" Irish jig, and putting a football with one of the pylons marking the end zone. Johnson also sent a thank-you OSU's way, donating $250,000 toward a scholarship fund.

EVER HEARD OF WOODSTOCK? This was Beaverstock. The day before the 2001 Fiesta Bowl, about 11,000 Oregon State fans nearly filled Arizona State University's basketball arena for a pep rally. OSU head coach Dennis Erickson told the crowd, "I tell you what, you're very special . . . thank you to the people who supported OSU football through all the tough years. As well as this team, these fans deserve this week."

THERE WERE THE 75,428 FANS on hand for the 2001 Fiesta Bowl and an estimated 35,000 of them were Oregon State rooters. "It's incredible," said Mark Floyd, director of OSU's news and communications services. "That's double the number of tickets allotted to the university. I don't know how all of those people got in."

THESE ARE THE "BEFORE" AND "AFTER" versions of Oregon State head coach Dennis Erickson at the 2001 Fiesta Bowl. As the first Beavers on the field begin loosening up, Erickson (above) finds a spot on OSU's bench at Sun Devil Stadium and takes a glance at the game program. With Oregon State's 41-9 dismantling of Notre Dame complete, Erickson (below) has a few final words for the Beavers in the locker room.

30TH ANNUAL TOSTITOS FIESTA BOWL
JANUARY 1, 2001 SUN DEVIL STADIUM, TEMPE AZ

PRESS BOX
FIELD ACCESS PRE-GAME & POST-GAME ONLY.

1,2 (4) 180

NOTRE DAME VS. OREGON STATE

JANUARY 1, 2001, was not a good night for the Gipper. Jonathan Smith passed for 305 yards and Ken Simonton rushed for 85 as the Beavers outgained Notre Dame 446-155 in the Fiesta Bowl. OSU put the game away in the third quarter, outscoring the Irish 29-0 to take a 41-3 lead. Surmised Notre Dame head coach Bob Davie, "It's pretty obvious we got whipped." The final polls had OSU ranked No. 4 by the writers of the Associated Press Poll and No. 5 by the USA Today/ESPN Coaches Poll—the Beavers' highest-ever final rankings.

OREGON STATE'S SUDDEN FOOTBALL RESURGENCE became one of the biggest sports stories in the country in the autumn of 2000. Reporters from practically every major media outlet in the country were on hand for OSU's 41-9 win over Notre Dame in the Fiesta Bowl.

All-American
KEN SIMONTON

HEISMAN
TROPHY

Terry Baker - 1962 Winner

Ken Simonton
2001 Candidate

AFTER RUSHING FOR AT LEAST 1,000 yards in each of his first three seasons at Oregon State, Ken Simonton entered his final season as a bona fide candidate for the Heisman Trophy. OSU mounted a significant campaign to promote Simonton, part of which were notepads that joined the Beavers' 1962 Heisman winner Terry Baker with OSU's 2001 candidate.

ENTERING THE 2001 SEASON, the Beavers were defending Pacific-10 cochampions and their championship ring was featured on the media guide. Joining the jewelry, clockwise from the top, are head coach Dennis Erickson, running back Ken Simonton, cornerback Dennis Weathersby, center Chris Gibson, and linebacker James Allen.

It took over a century, but Oregon State finally made it to Philadelphia's Franklin Field—the nation's oldest college football venue still in operation—for a 2002 game against Temple University. The Beavers cruised to a 35-3 victory in their first East Coast appearance in 15 years, and much of the crowd of 20,162 was wearing orange and supporting OSU.

Mike Riley is introduced as Oregon State's head coach—again. The formal announcement on February 19, 2003, made Riley just the second man ever to return to the head coaching position at OSU. The first had been Bill Bloss, who led the school's first football team in 1893 and then came back for the 1897 season. Riley led the Beavers to a 55-14 win over the University of New Mexico in the Las Vegas Bowl that season, then a 38-21 win over Notre Dame in the Insight Bowl in 2004. It was the first time the Beavers had won bowl games in back-to-back seasons.

OREGON STATE'S TRIP to the 2003 Las Vegas Bowl was a homecoming for a number of Beavers, and four of them were featured on the cover of OSU's bowl game guide. Pictured here, clockwise from the top left, are linebacker Richard Seigler, linebacker Jonathan Pollard, safety Lawrence Turner, and running back Steven Jackson. The Beavers rolled over New Mexico 55-14, with Jackson rushing for 149 yards and a school-record-tying four touchdowns. After the game, he announced he would forego his senior season to enter the National Football League draft.

AFTER A SLOW START in 2004, Oregon State was one of the hottest teams in the country over the second half of the season. The Beavers won five of their last six games of the regular season, including a 50-21 win over Oregon, to gain a berth in the Insight Bowl. Waiting for them in Phoenix was Notre Dame, and the Beavers improved to 2-0 all-time against the Fighting Irish with a 38-21 win at Bank One Ballpark. Said OSU quarterback Derek Anderson, who passed for 358 yards and four touchdowns in the victory, "It was a big game for us. To bounce back from the start that we had in this season and finish like this, it's huge."

IT'S A LITTLE TOUGH to see Derek Anderson in this photograph, but the Oregon State quarterback must have a pretty good view of his target. It is November 6, 2004, and OSU is playing No. 1-ranked Southern California at Reser Stadium in a thick fog, but Anderson managed to pass for 330 yards in the Beavers' 28-20 loss. The visibility was bad enough that USC's radio announcer opted to broadcast part of the game from the sidelines rather than the press box. From Scappoose, Oregon, Anderson quarterbacked OSU from 2002 through 2004 and left as the school's all-time leader in career passing yardage and total offense, broke single-season records for passing yardage and total offense, and set the mark for single-game passing yardage. He ranked No. 11 all-time in NCAA Division I for pass yards and No. 2 all-time in the Pacific-10.

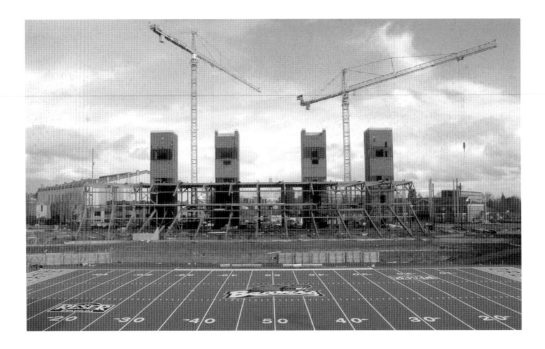

THE "RAISING RESER: EXPANDING BEAVER NATION" campaign began in the wake of OSU's success in the early 2000s. By January 2005, a new east grandstand (above) that would add 8,000 seats was rising with the four stair/elevator towers topped out and steelwork for the upper deck begun. The $93 million project was privately funded, with ground being broken on May 1, 2004. By late June, most of the structural work was complete (below) and seats were being installed. The facility also included a club, loge area, and skyboxes.

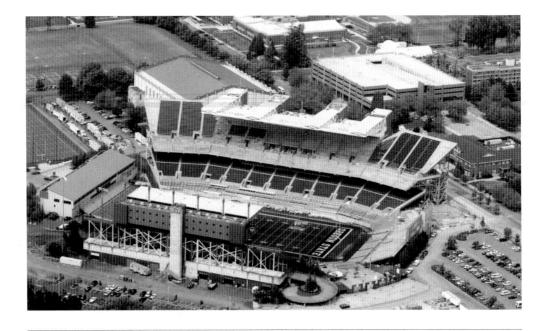

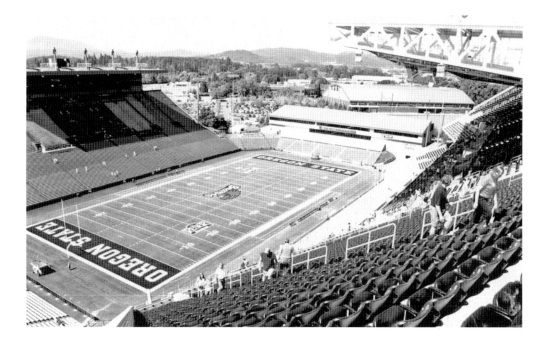

OREGON STATE FANS got their first look at Reser Stadium's new east grandstand on August 27, 2005. Most made the trek to the upper deck for the view of not only the field, but also the Coast Range in the distance. "It's going to put us in a new age," OSU fan Tim Carpenter said. "It's going to put us up there and teams are going to want to come in and play here now because we have facilities they're going to like to play in . . . it's even better than I thought it would be."

THE TWO HEAD COACHES who resurrected Oregon State football, Mike Riley (left) and Dennis Erickson, share a smile during the dedication ceremony for Reser Stadium's new east grandstand on September 3, 2005. Not long after, Riley exchanged his suit for coaching togs and led the Beavers to a 41-14 win over Portland State University.

OREGON STATE FOOTBALL

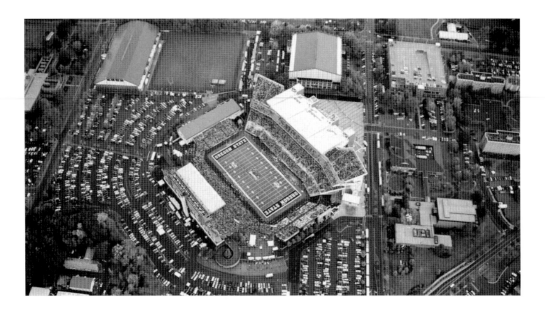

RESER STADIUM SHOWS its new look as Oregon State rallies to beat Boise State University 30-27 on September 10, 2005. The game drew a crowd of 42,876, a stadium record at the time, and OSU would attract at least 40,000 fans for each of its six home games that season. The Beavers set attendance records in the initial year of the stadium's new configuration, averaging 42,190 per game. At season's end, the single-game record was 42,960 for a 20-17 loss to Stanford on November 12.

VIEWED FROM ACROSS Twenty-sixth Street, the new Reser Stadium east grandstand displays a form that blends with the brick construction of much of Oregon State's campus.

OREGON STATE WIDE RECEIVER Mike Hass (above) and placekicker Alexis Serna (below) were named the nation's best players at their positions for the 2005 football season. At the College Football Awards on December 8, Hass earned the Fred Biletnikoff Award and Serna received the Lou Groza Award. Both Hass, a senior from Jesuit High School in Portland, Oregon, and Serna, a sophomore from A. B. Miller High School in Fontana, California, arrived at Oregon State as walk-ons and eventually earned scholarships.

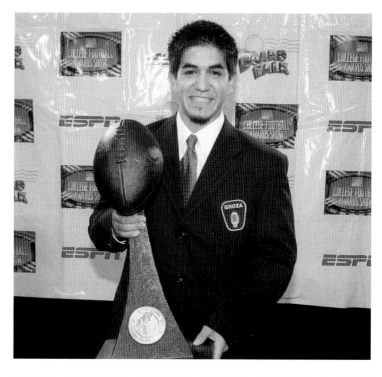